Collins Artist's Little Book of Inspiration

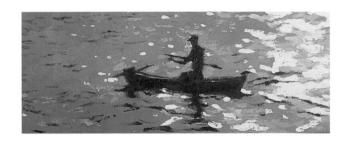

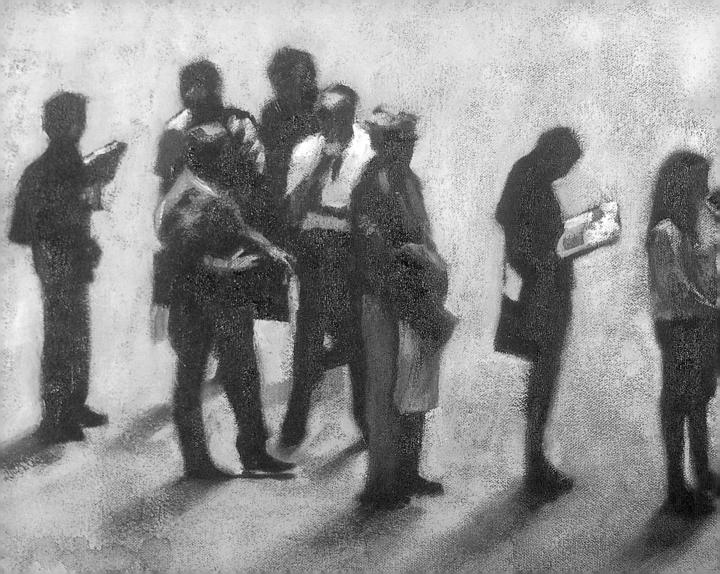

Collins
Artist's Little Book of
Inspiration

Hazel Soan

To John and Sean, my inspiration.

First published in 2008 by Collins, an imprint of HarperCollins Publishers 77-85 Fulham Palace Road London W6 8JB

The Collins website address is www.collins.co.uk

13 6 5 4

© Hazel Soan, 2001, 2008 Based on material from What Shall I Paint?

Hazel Soan asserts the moral right to be identified as the author of this work

All rights reserved. No part of this publication may be reproduced, stored in a retrieval system, or transmitted, in any form or by any means, electronic, mechanical, photocopying, recording or otherwise, without the prior written permission of the publishers.

A catalogue record for this book is available from the British Library.

Editor: Geraldine Christy Layout Designer: Heike Schüssler Photographer: Laura Knox

ISBN 978 0 00 727490 1

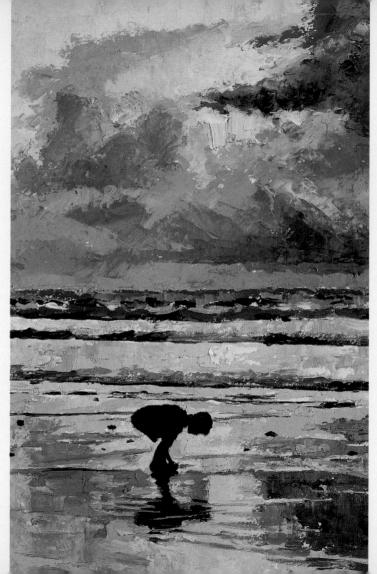

Colour reproduction by Colourscan, Singapore Printed and bound in China by South China Printing Co. Ltd.

Acknowledgements
The author and publishers are grateful to the following source for artists' quotations throughout the book: Artists on Art (pub. John Murray, 1976). The quotation on page 55 is taken from The Philosophy of Andy Warhol (From A to B and Back Again) (pub. Harcourt Brace, 1975). The painting on page 47 is reproduced courtesy of London Contemporary Art.

page 1: Lake of Stars,
12 x 36 cm (4/2 x 14 in),
oil on board
page 2: Everybody Waits
for Something,
28 x 45 cm (11 x 18 in),
oil on canvas
page 4: Seeker on the Shore,
50 x 25 cm (20 x 10 in),
oil on paper
page 8: Future Expectations,
43 x 56 cm (17 x 22 in),
watercolour
page 52: Material World,
38 x 61 cm (15 x 24 in),

38 x 61 cm (15 x 24 in), acrylic on wood page 68: **Over the Dunes**, 20 x 30 cm (8 x 12 in), oil on canvas

Collins Artist's Little Book of

Inspiration

Contents

Introduction	7
Finding Inspiration	8
Tools of the Trade	52
The Adventure of Painting	68
Index	128

Introduction

In a diverse and magnificent world we are inspired by both natural creation and man-made invention. Even the constant bombardment of images in the media has added to our visual repertoire. It is not just the picturesque that can move us to paint - everything and anything can interest us.

So how is it that, with all this pictorial wealth on offer, confrontation with a demanding sheet of all-too-white paper or a blank canvas often provokes the question: 'What shall I paint?'.

The elements of painting

To be inspired to paint you need to know what a painting requires, so I have set this book out in three sections. The first section, 'Finding Inspiration', looks at the basic elements of a painting, what to look for in a subject and how to find it.

The second section, 'Tools of the Trade', looks at what we paint with and the surfaces to which colour is applied; the medium will influence the painting, and can have a bearing on your choice of subject. I have limited the scope of this book to watercolours, oils and acrylics, but most of what is said will apply to other media as well. The third section, 'The Adventure of Painting', puts your new-found vision into practice. Each chapter relates to different environments and explores the inexhaustible inspiration available.

There are chances throughout for you to put theory into practice with suggested projects. I also include some demonstrations. Soon you will find even the clutter on a table will inspire a painting or the queue at the bus stop will excite you to open your sketchbook!

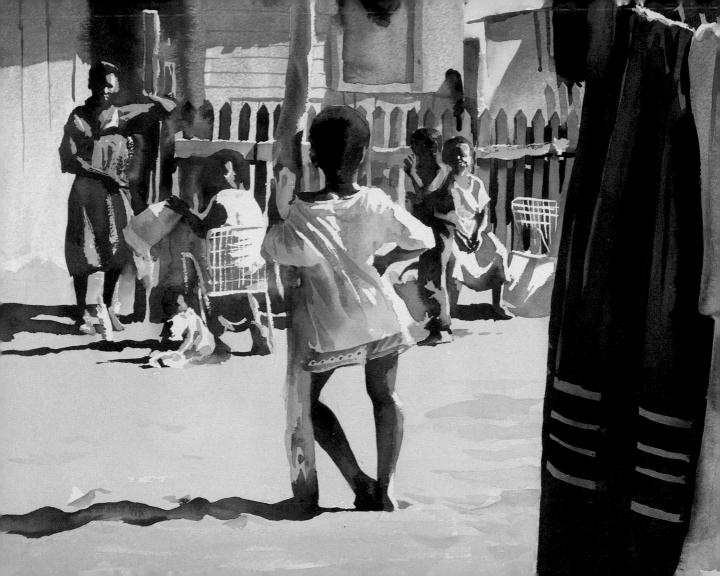

Finding Inspiration

How do you decide what makes a good subject for a painting? You can rely on tried and tested themes, the timeless stalwarts that historically make good pictures: the bowl of fruit, the vase of flowers, the seated figure or portrait, or the classic view. But what about other ideas? Much around us, the details and small corners, the events that move us emotionally - these too are visually interesting, but not always immediately obvious to us as inspirational subjects for paintings.

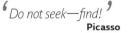

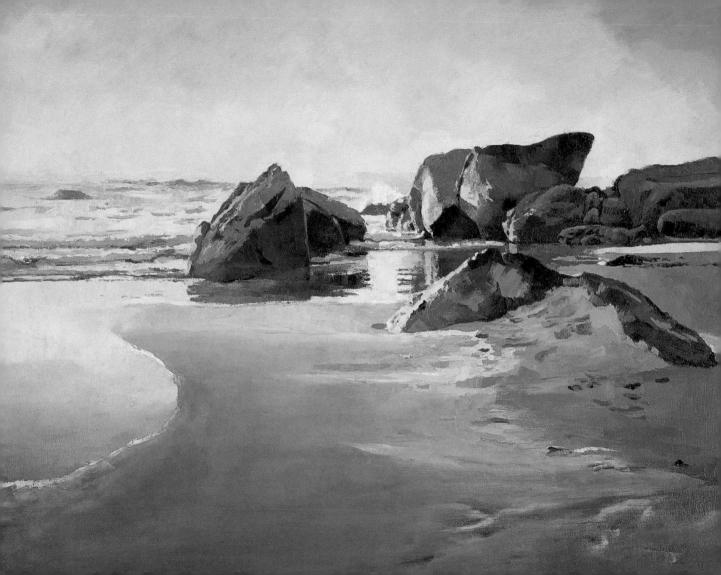

Learning to see, learning to feel

... the artist has only to trust his eyes.

Most people probably accept there is nothing the artist cannot paint, but, even knowing this, still find it difficult to pick out from the view in front of them the inspiration for a good painting. They may go in search of a subject but find it wanting in some way, or compose their picture without real conviction because they are unsure of its worthiness as a subject for a painting.

In practice there are times when the desire to paint is strong, but it is difficult to find a satisfactory grouping of objects or a perfectly composed view to act as the catalyst to get started. What is it that actually kindles a painter's interest?

Painting starts with seeing. We are easily attracted to pleasant groupings of objects: a setting in the landscape, the colours of flowers, a charming child or an interesting face. We are often struck by the effects of light and shadows.

The less tangible, such as atmosphere, mood, or an unusual incident, also engages the eye, while pattern, repetition and contrasts have strong visual appeal. Familiarity with the subject, a face we love, a memorable room, or food, can also stir us to reach for the paintbrushes.

Finding inspiration

Sometimes, however, inspiration is not torthcoming. Then, instead of looking at the subject itself, you will need to look for the two-dimensional qualities sought by the picture plane: the nuances of light, line, shape, colour and incident.

The aim of this book is to show you the elements that make up paintings, so that you can see them all around you and find a never-ending supply of subjects - in effect, to create your own inspiration.

In the Beginning 71 x 102 cm (28 x 40 in), oil on canvas

Through an artist's eyes

Painters lay colours, lines and shapes upon a flat surface and these are transformed into landscapes, people, objects and feelings. If you can view the world through eyes that fluently translate three dimensions into two dimensions you will be overwhelmed with painting ideas.

Painting starts with the eyes. There is a threefold pleasure and purpose in painting - the act of looking, the making of the painting, and the response to the outcome by others - but it all starts with seeing. Training the eye to see is the first step to a successful painting.

Thinking two-dimensionally

The things that make interesting paintings may not be subjects that attract the eye per se, but groups of elements that form a particular set of shapes, colours or tones that the artist recognizes will make a successful composition or colour scheme upon the flat picture surface.

The Studio Chair 122 x 91 cm (48 x 36 in), oil on canvas This painting is composed around the shapes of the spaces between the wooden rungs of the chair. To make it easier to draw shapes in proportion use the length of an outstretched pencil to compare the widths of the space-shapes with their heights.

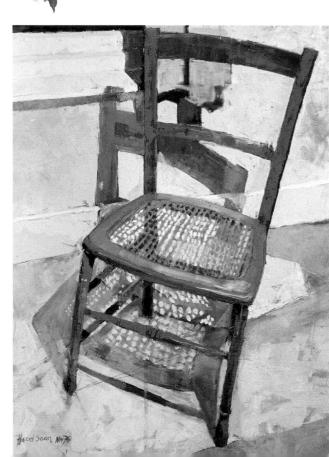

Getting in shape

The simplest way to train the eye is to look at shapes and outlines. On the flat surface of a painting it is easy to understand that the shapes of spaces between parts are going to be as important as the shapes of objects themselves. The proportion of those space-shapes is also crucial to determine their outlines.

Look at the spaces under chairs and tables, the gap between an arm and the trunk of the body, the space inside the handle of a jug, or the spaces under tree canopies.

> Digging for Treasure (detail) 76 x 65 cm (30 x 22 in), oil on canvas The overall shape of the silhouetted group is as important as the shape of each figure and the spaces between them.

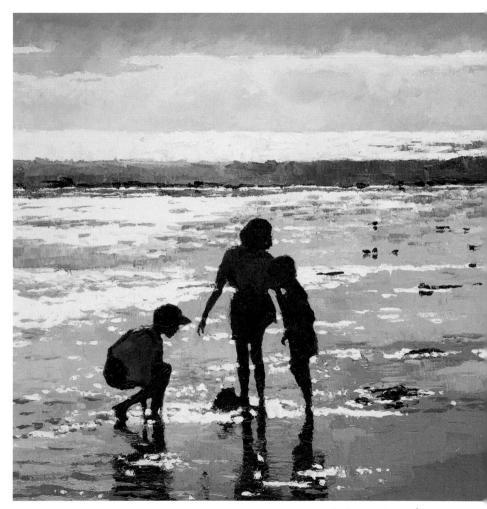

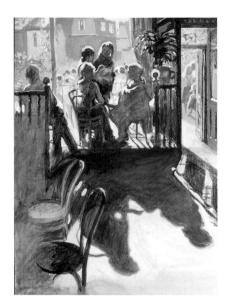

Left: Long Shadows in Parsons Green

71 x 46 cm (28 x 18 in), watercolour. gouache and conté cravon on paper Once you start to see in shapes. drawing becomes much easier. Perspective falls into place because the lines are found from the angled sides of the shapes they bound. Use the length of the pencil to find relative proportion between near and far objects.

Right: 'La Cuenta. Por Favor' 20 x 20 cm (8 x 8 in), watercolour Idling over a cup of coffee on holiday I noticed how interesting the money looked upon the plate - a tiny fragment from amongst the whole scene of the marina, but it provided a delightful subject for a 30-minute sketch.

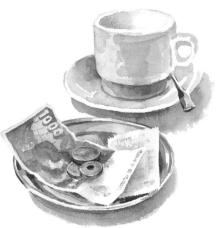

The shape of things

Now start observing the shapes of the items themselves. See their height and width, their overall proportion, not the surface features.

Try to outline the correct shapes, or block them in with flat brushstrokes from the inside out. Alternatively, create their shapes by painting only the shapes that surround them

Next look at group shapes - a cluster of trees, or perhaps a knot of people. Do not limit your eye to individual items; look for shapes of the same tone or colour. For example, there may be a dark shape under the eaves of a house that includes a door, a window, a shadow and half of a bush, or the skirt of a seated woman may merge with the chair and both may merge into the shadow on the wall. For the artist these united shapes become one item on the flat picture plane.

Assume nothing

A bobbing head is the mark of an observant eye. Constantly refer to the

Below: Day by Day

20 x 28 cm (8 x 11 in), oil on canvas In reality this particular stretch of beach on Lake Malawi was more cluttered. I simplified the scene to impart the spirit of the task I had watched performed day by day along the lake.

source of your visual information. Never presume you know what anything looks like, no matter how familiar - on few occasions will the light falling on your subject be repeated in exactly the same way. Observe it as you have never seen it before and that freshness of vision will translate into your paintings.

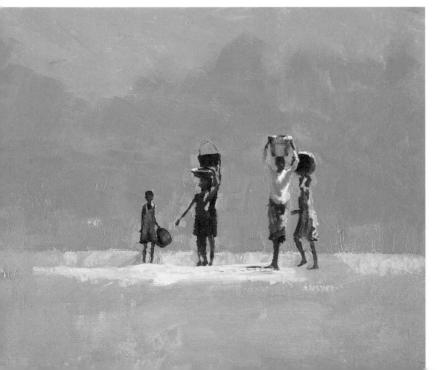

Simplification

When you look at the world you do not notice or see every detail. You pick out that which interests you and catches your eve. A camera cannot be selective about what it sees, but the artist can be. It is this very selection of what really matters to you that makes a painting original.

If the shape of a group of objects has attracted you - a huddle of buildings on a skyline, perhaps - it is this that becomes your subject. If you forget this and get carried away with putting too much detail in the brickwork, for example, you run the risk of losing the essence of your painting. The more you can synthesize the particular elements that interest you the stronger your painting is likely to be.

Homing in

When observing the view let the eye roam back and forth, left and right, to find scenes within scenes within scenes. Clarification may involve homing in on tiny features, and sometimes your subject is a fragment of the whole.

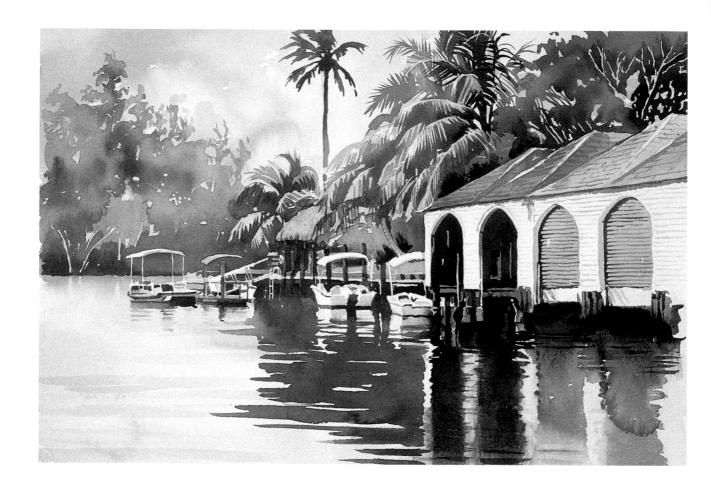

Left: Everglades 38 x 56 cm (15 x 22 in), watercolour It is the artist's prerogative to pick and choose from any subject whatever inspires them. Other things were happening in this view, but I included only the elements I wanted to paint. The resulting image has a stronger impact, and makes it clearer to 'read'.

Fragments of the whole

A tuft of grass on a dune can say as much about a beach as a painting of the entire shore: a pair of shoes may hint more at a person's character than a full-length portrait: and a corner of a table in an interior may be more interesting as an image than a picture of the whole room.

Distilling the subject

Sometimes the desired subject seems just too daunting to tackle. It may be a vast panorama, a busy street scene, a complicated building or a detailed fabric. To resolve this, stand back, half close your eves and look for the most obvious lights and darks, and the main lines and shapes. Concentrate on portraying these; you will find that simplification will strengthen the painting, not weaken it.

In the course of painting you may get carried away with details and forget to see the image as a whole. Holding on to your subject can sometimes be as hard as finding the right subject in the first place! Be single minded and purposeful.

Ask yourself. 'What did I first notice when I was drawn to this scene?', 'What makes it exciting?'. Keep this initial inspiration in mind to prevent yourself from overworking the painting and losing your way.

Getting involved

We all have different passions and emotions. Do not be afraid to record visually the objects and incidents that provoke your interest. The seemingly obscure statements made by small details may be far more meaningful in the end than a fully composed view.

Through painting you become acquainted with your subject. After you have finished painting a landscape or interior, walk into it and enjoy the familiarity of it. Touch the tree you have lovingly painted for the last hour; handle the objects on which you bestowed your time. This intimacy is an added bonus that many painters forget to enjoy as they pack up their paints and walk away.

PROIECT

Training the eye

Training the eye to see does not happen overnight. Practise by observing and drawing shapes and distilling the elements of a subject to its essentials, using any medium you wish. Do not judge vourself on results remember you are learning to see, not making paintings.

MATERIALS USED acrylic charcoal watercolour

THE SPACES IN RETWEEN

Pick a group of objects from the bathroom cupboard. Place the items in a line with gaps between them. Paint just the spaces in between and around the items. Be aware of the distances across each item to the next space. Aim to describe the items only by the spaces around them - and the items will appear as if by magic!

THE SPACES WITHIN

Observe and draw the spaces inside cups and jugs and their handles. Draw the shape of the spaces rather than drawing the items or handles themselves. I have used charcoal and white acrylic on stained paper.

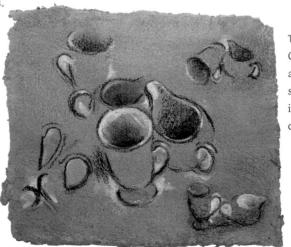

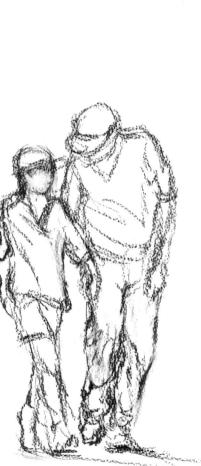

FINDING THE ESSENCE OF THE SUBJECT

Find a picture of something that stirs your emotions. I chose a photograph of a father leaning down to his son; the guiding link of hands seemed to represent fatherhood. Draw the image onto your paper looking only at the subject and not down at the page. Use lines back and forth over areas until you feel you have familiarized yourself with the subject. Resist the temptation to look at your drawing. When you have finished you will probably be horrified at the muddle on the page, but now start again.

This time you can look at your drawing while you try in a few meaningful strokes to distil from the image the lines you think best describe its meaning.

postscript

Follow these exercises by drawing the spaces under chairs and tables, the intervals between tree trunks and spaces under tree canopies. Always check that the height, width and proportion of the space corresponds to what you see.

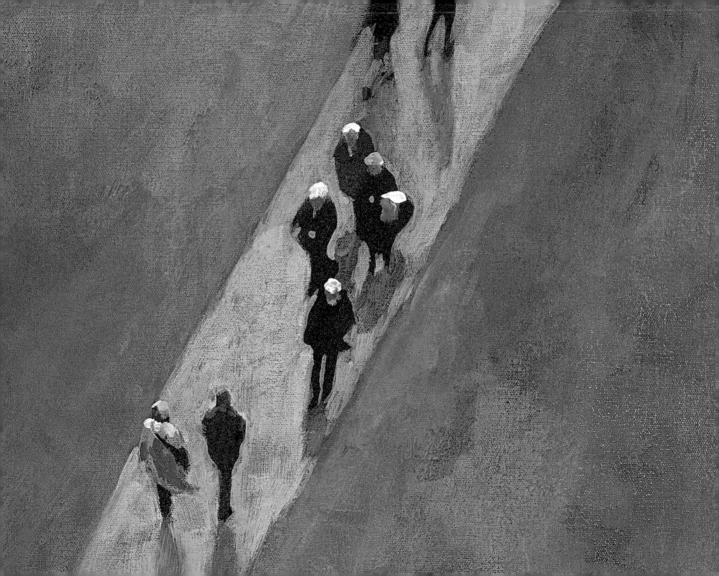

Discovering composition

The composition is the organized sum of the interior functions (expressions) of every part of the work. Kandinsky

> Every picture has a boundary that is determined by the limits of the surface on which it is painted. The actual painting takes place within that perimeter, though it need not fill the area, and the effect of the painting may be to extend well beyond its outlines. Good composition is fundamental; it is inspired by the subject matter, but not ruled by it.

Naturally good compositions occur all around us, though they are not always readily apparent. Somewhere within the scene is the painting-in-waiting; and recognizing it and translating it onto paper is the art of composition. This simply means being aware of a workable set of shapes, lines, colours and tones

that, grouped together, make an inspiring pattern on the picture surface.

Finding the painting

Obviously picturesque views would appear to make good paintings, and often there is a sense of obligation to paint them, but they may not immediately have what a painting needs to be interesting. The artist must therefore either jiggle the view around or perhaps take a small part of the view that provides a more satisfactory composition.

Readymade compositions

A satisfying, asymmetrical, but balanced, arrangement of elements usually ensures a successful composition. If the shapes, colours and tones are well arranged you will find it easier to make the painting work, but this does not mean that it has to be harmoniously balanced, or overly planned. Jarring or obscure arrangements make interesting compositions too. All you need is to recognize what will work on the two-dimensional picture plane.

View from the London Eve (detail) 43 x 28 cm (17 x 11 in), acrylic on canvas

The morning after the night before, 1, 1, 2000 20 x 20 cm (8 x 8 in). watercolour and ink The composition is unbalanced. but the sentiment is strong and the sketch remains as a good New Year memory. Is that not a good enough reason for a painting?

The source

If you have control over the physical elements you are painting, as in a still life or portrait, you can move parts of the actual subject around until the whole arrangement pleases the eye. It is easier to glean your shapes, colours and tones direct from the source than to make wild guesses about what might look better.

In the landscape you cannot always find perfect compositions - few of us can move mountains! Sometimes you must sacrifice literal truth for pictorial success. Always remember the painting lives on independently of its source of inspiration. Even if your painting intends to be a truthful record of the view, you may have to make alterations to the composition: move trees closer together or leave out a few fields perhaps. Free yourself from the obligation to paint everything in front of you; that is not a recipe for success.

Sketching

Filling a sketchbook with ideas before embarking on a painting enables you to respond quickly to the inspiration of your subject and to find out what really interests you, without having to worry about planning your composition. These immediate unplanned images are often the most exhilarating work of an artist. and it is worth remembering that it is also possible to over-compose a painting to the point where predictability kills off its life. Pay heed to your sketchbook; it can teach you much about how you see and what excites you.

How to compose

To find the two-dimensional layout of the three-dimensional world look through a viewfinder. I often use my index fingers and thumbs to make a frame, but the best way is to hold two L-shaped pieces of card together. You can make any rectilinear shape to suit the view or the painting. As you look through the viewfinder move it around until you find the best layout within the rectangular space. Half close your eyes so that you can see tonal balance and relative shapes. Transition II 20 x 28 cm (8 x 11 in), oil on canvas The division of a sky-meets-land composition is a good starting point. Here, the horizon is placed above the centre line to avoid dividing the painting in half, and the line of rocks is balanced by the line of surf and the reflection.

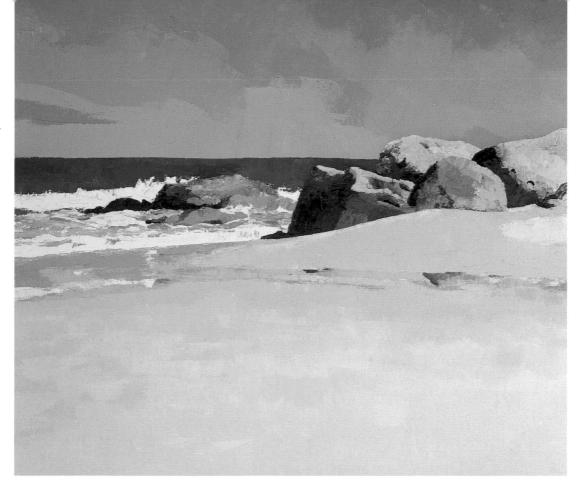

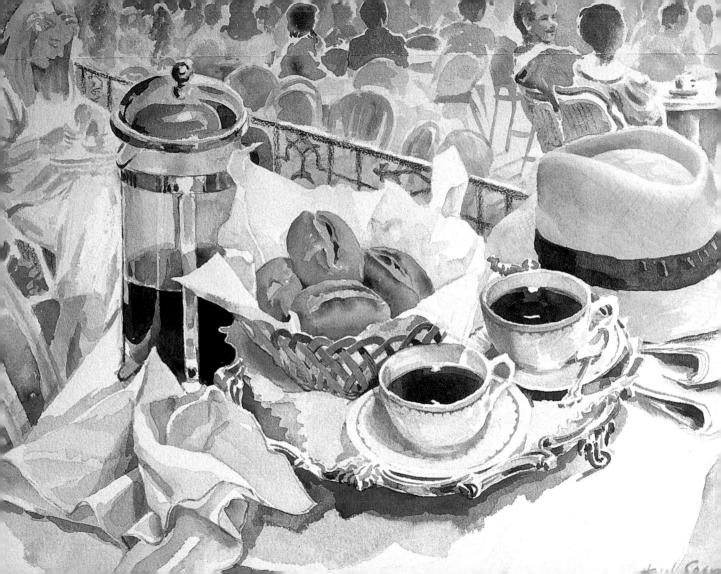

Left: Breakfast on the Terrace 43 x 58 cm (17 x 23 in), watercolour A lot is happening in this painting, but by organizing the composition of the items in the foreground the background activity could be painted in with more abandon.

The focal point

Usually the subject of your painting will be the focal point, the place in the painting you wish to draw the viewer's eve towards. Sometimes, of course, the subject is intangible - an atmosphere or an emotion - but there may still be an area of the painting, large or small, that you wish to emphasize.

If the subject of your painting is a particular feature place its position within the boundary of the composition before drawing the peripherals. There is nothing more dispiriting than drawing a picture starting from the edges, only to find the main feature is too far over to one side and you have to start all over again.

The picture plane

To simplify drawing the composition imagine there is a pane of glass held vertically in the viewfinder. This is your picture plane. Trace the main shapes and lines onto this imaginary glass. Point your finger into the middle to find a central reference and work out from there.

Flow lines and repetition

Within your view look for lines that lead the eye from the edge of the composition towards the main features or focal point. or that lead the eye out from the centre of the painting to the perimeter and beyond. Notice other lines that repeat or echo the lines of the main feature. These emphasize your focus of interest, though you may not even realize that they have attracted you until you start to draw the composition. Examples could be the direction of a pathway echoed in the rhythm of some branches, the edges of items on a table converging to a common point, or the position of limbs paralleled in the folds of clothes. Repetition of a shape can also be visually interesting.

There are no rules in painting, but generally horizon lines are better placed above and below the centre line, and main features not placed dead centre. A subject's power to convince will rely on shape, colour and tone. Think twodimensionally; use shadows and spaces to help define solid forms.

PROJECT

Everyday inspiration

Now it is your turn to discover the potential compositions in your immediate vicinity. Use a viewfinder if it helps and do not be embarrassed to be seen looking through your framed fingers. Any medium will do. I have used oils on paper and a size 9 brush.

MATERIALS USED oils paper

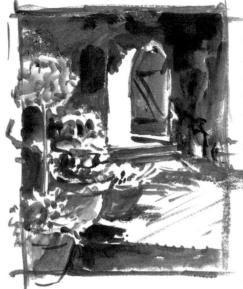

ITEMS IN RELATION TO FACH OTHER

Go round your home and garden and find some readymade compositions. Draw quickly, but place the items accurately in relation to each other on the page. A pile of ironing provides interesting shapes.

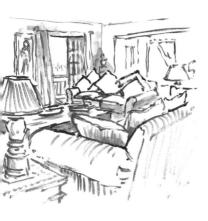

WIDE VIEW

Now take any view, inside or outside; I picked the sitting room. Hold up your viewfinder as near to your eyes as possible so that you see the largest view. Using a brush, sketch the main elements of the image. Does it make a good composition?

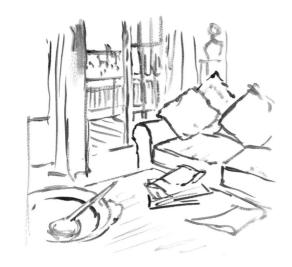

NARROWING THE FIELD

Next take a section of the view, not quite as wide as the first, and by moving the viewfinder around try to pick out an interesting group of shapes. Make another quick sketch with your brush.

You can check the strength and balance of your composition by looking at the sketch reflected in a mirror. If you are unhappy with it start again.

CLOSING IN ON A DETAIL

Finally, go in close on a detail within the view, and make a quick sketch noting the balance of light and dark. I chose the pile of magazines on the coffee table.

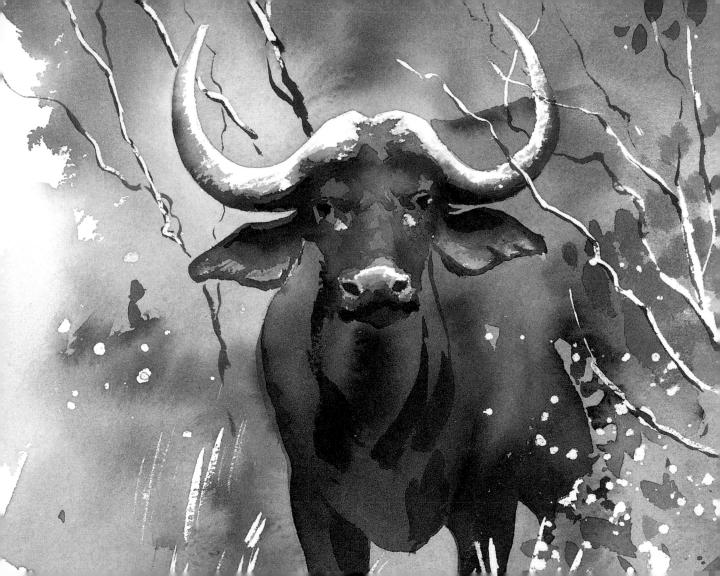

Responding to colour

Give me mud and I will paint you the flesh of Venus.

Colour, with all its cheerful connotations. is often the inspiration for a painting. But it is not just the bright colours of flowers, clothing or sunsets that attract the eye. The muted colours that play across a landscape, the subtle nuances of a person's complexion or the greys of urban drizzle are equally enthralling for the artist, and even the contemporary colours of the plastic world have a garish charm. So with all this wealth of colour around how can you choose what will translate well into a painting, and how faithful do you need to be to the colours vou see?

Your painting may look like a view across a valley or a group of children at

play, but in reality it is a collection of colours on a flat surface. It needs to work as a painting first, separate from its inspiration, to truthfully tell the tale of the interest you felt in the subject.

Under a different light source, such as sunlight, cloud cover or artificial light, colours may vary quite dramatically. This fact alone frees you from the obligation to copy colours exactly. You can take what you see and exaggerate or mute colours to make the painting stronger. Many subjects that lack immediate appeal are no longer ruled out if you can see the tiny differences between variations of colour.

Interaction of colour

All colours, except the primaries of red, yellow and blue, are made up of two or three of those primary colours; and a colour that contains just two of the primaries looks stronger if placed next to the third. So if you want to bring out the richness of an orange flower, say, or a wonderful head of auburn hair, paint a bluish colour next to the flower or head.

Voveur (detail) 28 x 20 cm (11 x 8 in), watercolour

Natural opposites

Opposite colours, such as orange and blue, are called complementary colours because added together they make up the full complement of three primaries. In the natural world we can find numerous complementary colour contrasts.

A dialogue of two contrasting coloured areas dominating the picture, such as beach and sky, make a strong image. Look out for contrasts when the colours are more subtle too: yellow-ochres, redbrowns and blue-greys, for instance.

The Patio

23 x 28 cm (9 x 11 in), watercolour The Burnt Sienna of the patio looks very orange. By adding blue, the complementary colour, into the shadows, the orange can be muted. There is a wash of Burnt Sienna and touches of Cadmium Red under the foliage to dull down the greens and prevent them making the pots look too red.

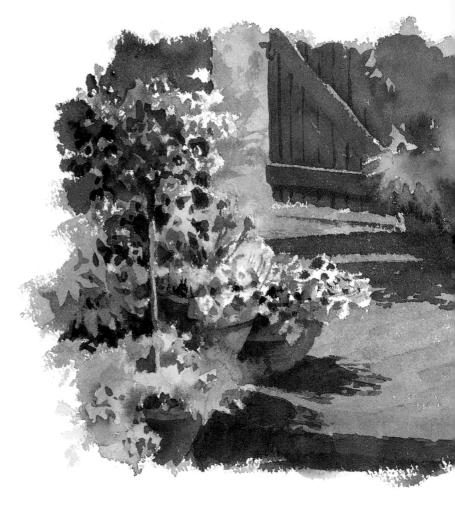

Using colours

In painting we can use the interaction of opposite colours to enhance and detract. By mixing a complementary colour with its opposite we can gradually turn it towards browns and greys.

A colour will push an adjacent colour away from itself towards its opposite. This comparative effect is common to most things in life; for instance, a tall person next to a short person will make the tall person appear taller and the short person seem shorter. A red next to an orange will force the orange to look more yellow, pushing it away from red around the colour circle towards green.

When we look for the effects of comparisons around us colours leap out from their surroundings. Red flowers, for example, look richer on dull days than in warm sunlight as the surrounding cool dull greens push them deeper into the warmth of red. A mauve cloud will make the sky around it appear more blue.

Altered colour

The perceived colours of objects are altered by tinted and reflected light. The white of a boat hull lit by the yelloworange light of sunset is tinted a golden yellow, while the shadows cast by ropes and fenders take on a complementary blue. Light or shiny-surfaced items reflect brightly coloured adjacent objects. A red tomato on a white kitchen top shares its colour with the surface beneath.

As you paint you will notice more subtle effects. Look for painting ideas on polished wood, crockery against white cloth, or on newspapers and alongside any reflective or wet surfaces.

Coloured light may be fleeting, so keep hold of the inspiration in sketchbook notations or on camera.

Colour and mood

Colour also has temperature; for instance, red is warm, while blue is cool. Reds, yellows and oranges, light bright tones and energetic brushstrokes bestow a cheerful mood on paintings. Subtler warm colours and tones tend to be uplifting rather than vivacious in their effect. Jarring combinations of vivid colours combined with brusque marks can even suggest anger.

Cool colours, especially blues, evoke calm, restraint, or melancholy. If you wish a subject to be peaceful look for the blues within the view, and if you want joie de vivre seek out oranges, warm yellows and reds. Emphasize these with their complementaries.

To assess temperature look carefully at each colour in relation to the next. Ask yourself, 'Is this colour redder or bluer than that one, even by the tiniest amount?', 'Is it colder or warmer?'. It is these differences in colours, one against another, that build any subject into an interesting painting.

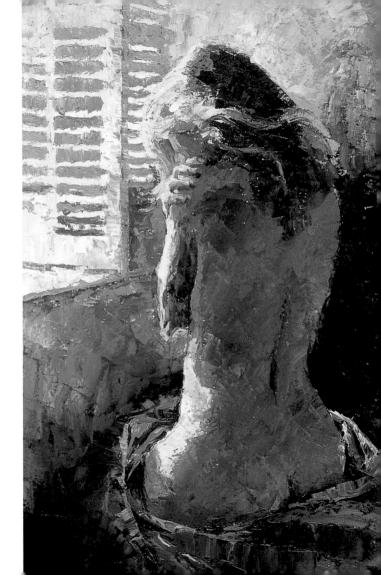

Left: In the Morning Light 38 x 28 cm (15 x 11 in), oil on paper

This painting is almost all blue with just a few dashes of yellow in the areas of light. The mood created by the blues is easier to read in paint than to put into words; it evokes both tenderness and vulnerability without being in the least depressing.

Right: Christmas at the Ritz Club 20 x 20 cm (8 x 8 in), watercolour Lamplight and firelight

bathe the room with a warm yellow glow. Yellow Ochre is the perfect colour for this warm light.

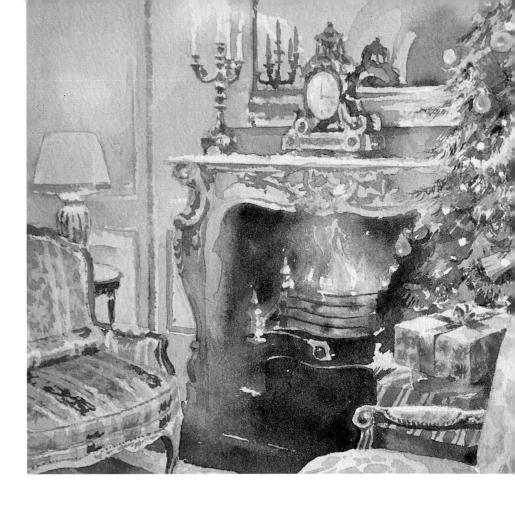

PROJECT

Mixing colours

One of the best ways to see colours for painting is to assess the temperature of a colour by asking yourself if it veers towards red, the warm side of the spectrum, or towards blue, the cool side. In an ideal palette you will have a cool and a warm version of each colour. The swatches here are watercolours.

ORANGE COLOUR MIX

To make bright colours from two different hues, mix two near primary colours of the same temperature. This bright orange is made with Cadmium Red and Indian Yellow, both warm versions of their colours.

COLOUR SWATCHES

Here is a suggested palette of colours that includes one warm and one cool colour of each hue for you to practise with.

WARM Cadmium Indian Sap French Burnt Yellow Red Yellow Ochre Green Ultramarine Sienna COOL Viridian Alizarin Aureolin Prussian Sepia Raw Crimson Umber Blue

For a slightly less bright colour, mix two colours of different temperatures. This orange is made from Alizarin Crimson and Indian Yellow. Alizarin Crimson contains a touch of blue, so the mix is slightly cooler.

Here two cool versions of warm colours, Alizarin Crimson and Aureolin, are mixed to make a cooler, less bright orange, as the involvement of all three primaries moves the colour gently towards black.

GREEN COLOUR MIX

The brightest green is made from Aureolin and Prussian Blue (two cool colours).

A less bright green is mixed from warm Indian Yellow and cool Prussian Blue.

A dull green results from mixing Indian Yellow and French Ultramarine (two warm colours).

PURPLE COLOUR MIX

The brightest version will be made from a red leaning to blue, Alizarin Crimson, plus a blue leaning to red, French Ultramarine.

A duller mauve is made from two cool versions of red and blue, Alizarin Crimson and Prussian Blue.

A mix of French Ultramarine and Cadmium Red is duller still as the Cadmium Red begins to lean towards the yellow side of the spectrum (three primaries involved).

Prussian Blue (cool blue leaning to vellow) and Cadmium Red (warm red leaning to yellow) make a lovely dark.

postscript

Remember colour is relative. All the oranges are warm colours in relation to blue, but there are cool versions of warm colours and vice versa.

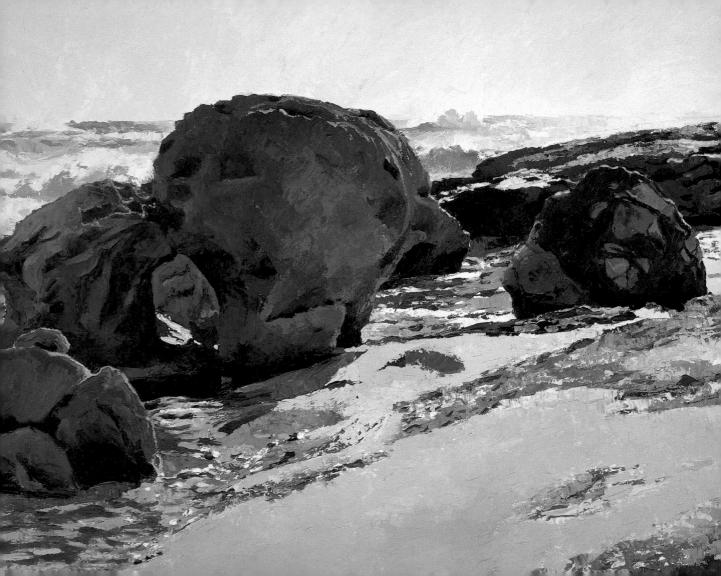

Valuing tone

The first two things to study are form and values.

Colour may be a great inspiration, but tone is more vital to the success of a painting, and it is therefore a more important factor to consider when deciding what to paint.

Tone, often referred to as value, is the degree of lightness or darkness of a colour. Different colours may have the same tone and one colour may have many different tones. Light or the lack of it determines the tone.

In vision tonal variation enables us to distinguish one object from another and to discern and recognize form. Its relative values permit us to judge distance and perceive space. On the flat picture surface we use tone to give the illusion of these elements; in other words, to suggest three dimensions and to create space.

An interesting play of tones, be it a stilllife group, a broad scene or a small detail, makes it a possible subject for a painter. Generally, if a painting works well tonally it is likely to 'work' overall.

To see tone more clearly look through half-closed eyes. By removing some of the distracting colour it is easier to differentiate between tones. Shapes of a similar tone merge together, while areas of different tones stand out.

Guardians 56 x 76 cm (22 x 30 in), oil on paper

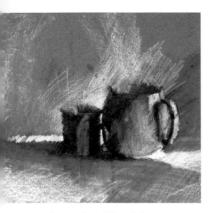

Above Left: Spilling Light 56 x 71 cm (22 x 28 in), conté crayon On a piece of mid-tone paper I only needed white and black conté crayon to study the tonal values of this mug and jug. The sweep of the white conté strokes indicates the sense of light entering and spilling out of the two items

Above Right: Mug and Jug 61 x 76 cm (24 x 30 in), oil on canvas Here I chose just two colours -Yellow Ochre and French Ultramarine - plus black and white, to explore the tonal variations in paint. Painting with just a few colours enables you to concentrate on tonal differences more easily.

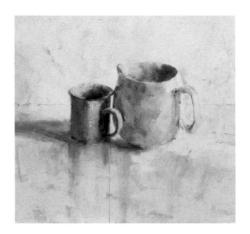

Strong and subtle

Amongst any group of items or figures there will be a play of tones. Sometimes these are blatant, sometimes subtle. Strong tonal difference is easy to see, but tiny nuances present just as much pleasure to the artist. Only by trying to record them in paint do you realize just how captivating the differences can be. Let the natural irregularities of mixed paint or unevenly drying washes play their part also in creating tonal variation.

Tuning in

When you are observing tone ask yourself, 'Is this colour darker or lighter than the one next to it?'. Try to paint the correct relative tones. Remember that the tones of spaces between elements are as important as the tones playing across items themselves and any area of tone may not be limited to a material form: it may include a shadow, for example.

Look for the lightest and the darkest areas in the view first. All the other tones will fall in between these two. Comparing colours with a piece of black or white card will help you assess how dark any tone is in relation to black, or how light in relation to white. Sometimes it is hard to decide which tone is the darker between two, especially with very different colours - keep half-closing your eyes to help you.

Small variations in tonal juxtapositions bring a painting alive, literally because they make it look real to our eyes. Strengthening tonal differences clarifies a muddled painting because it enables us to read the picture surface.

Light and contrast

Light is crucial to the artist. Its changing countenance is a great inspiration, and dramatic light effects are the subject of many paintings. The subject could be the shaft of light through a window or a strongly lit still life. Whatever it is, a wide range between the darkest and the lightest tone adds strength and drama.

If a group of objects you have chosen to paint lack fascination place a light source almost directly behind them. View the subject into the light, contre-jour, or against a dark background. The light will escape around the edges of the objects, contrasting small lights against rich dark tones.

Daylight

In the landscape move your position to take advantage of the most favourable light source. Light falling on either side or from behind the subject, rather than lighting directly from the front, will make a more lively play of tones.

Below: Study of a Cat 13 x 18 cm (5 x 7 in), watercolour

In these tonal studies the touch of colour is used as the mid tone. It also adds to the cat's identity.

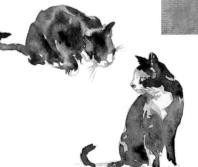

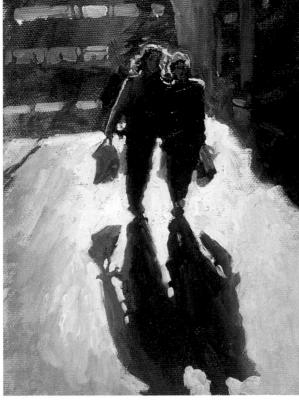

Above: Bussing Home 18 x 13 cm (7 x 5 in), oil on canvas Painting into the light makes an interesting image as shapes turn into silhouette and small areas of light break out like haloes around dark features.

Highlights and shadows

The bright light of a sunny day often bleaches out the colour of objects it strikes, and throws other areas into a unified darkness, thus simplifying the view into a few main tones. In watercolour the use of the untouched white paper to represent the highlights is a powerful technique. In oils brush or palette-knife strokes of pure or tinted white bring these areas alive.

Shadows nearly always carry a colour either tending to the opposite of the colour of the light source or tinted by reflected colour similar to the light. However dark or light the shadows appear you can strengthen or dilute them to suit the painting and the mood you wish to create.

Energy

As you look at items or views imagine the light being drawn into them, flowing over them, or spilling out of them. When you paint translate this energy into the painting by the gesture or direction of the brushstroke.

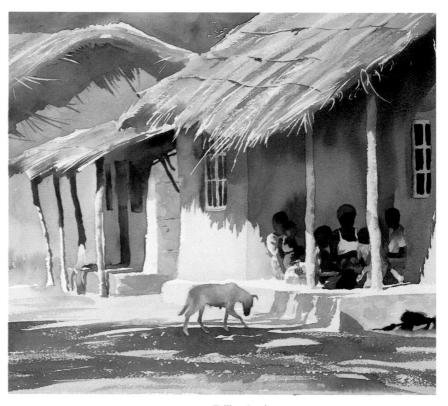

Telling Stories

43 x 66 cm (17 x 26 in), watercolour

Bathed in shadow under the thatch, the features of the group of people become indistinguishable. In watercolour you can use wet-in-wet technique to blend colours and simplify.

Above: Holiday Reading 20 x 25 cm (8 x 10 in), watercolour The light colours and delicate tints of this watercolour painting of a sunlit table create a cheerful holiday mood.

Right: The Grass Veil 18 x 25 cm (7 x 10 in), watercolour The distant fields merged together in similar tones. To vary the tone I ducked down. lowering my eye level, so that the foreground grasses were above the horizon. The grasses are now both darker and lighter than the view beyond, creating interest.

Lack of variation

Sometimes there is little difference in tone across a view. This may in itself be interesting, but most pictures need some contrast of tone. By changing your viewpoint you may find a better composition, perhaps by bringing something from the foreground across the view. The proximity of the foreground feature will be a darker or lighter tone than the background and so provide the tonal contrast.

The tenor of tone

Like colour, tonal values can create specific moods and atmospheres. Light colours tend towards cheerfulness and

bright colours are upbeat, whereas dark colours imply gravitas and sobriety. Paintings in a higher key, with lighter colours, feel more lightweight than those in a lower key. This enables you to create an overall mood with a predominant tone and to look for that mood in the subject.

You can also use tone to enhance colour. A sallow colour makes the colour beside it appear more lively, while a pallid one makes an adjacent colour more cheerful and bright. In any view isolate small areas from the predominant tone and colour: alone, they may sing out. Do not be afraid of painting dark washes, or of laying very rich colour as a first wash.

PROJECT

Monochrome painting

One of the most effective ways of learning about tonal values is to paint in monochrome. Without the distraction of painting colour you can concentrate on the differing tones. The resulting studies can also be very striking. For these projects I have chosen to work in watercolour, but feel free to use oils or acrylics if you prefer.

MATERIALS USED watercolour watercolour ink

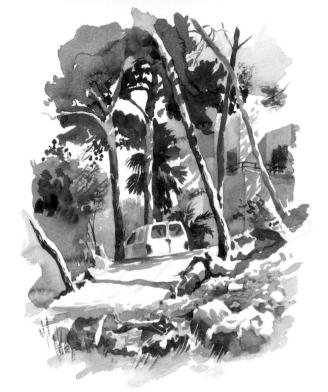

OBSERVING TONAL VARIATION

Go outside, with one dark colour: I took Indigo. Half close your eyes on any scene with a play of dark and light shades. Paint it with your one colour. Focus all your attention on the variation between tones and ignore the local colours of the subject.

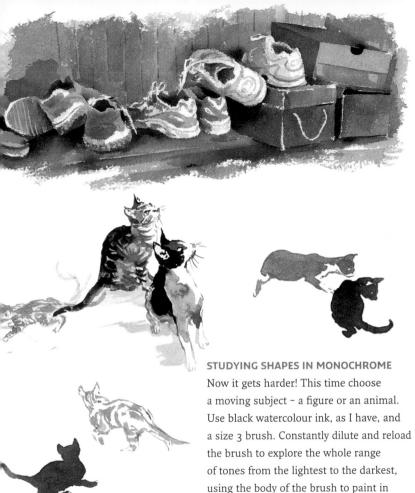

shapes rather than line.

CREATING FORM WITH RELATIVE TONES

Select any pile of clutter or group of objects on a table, shelf or floor. Do not arrange them. I chose my son's untidy shoes on a shelf. Again, using just one colour - I used Sepia - create the three-dimensional forms of the objects chosen. Leave white paper for the lightest areas and note the darkest darks from the outset. Try to see areas of similar tone, so that the objects become linked.

postscript

As you engage in painting tone the contrasts and subtleties become more and more absorbing, effectively fuelling your inspiration.

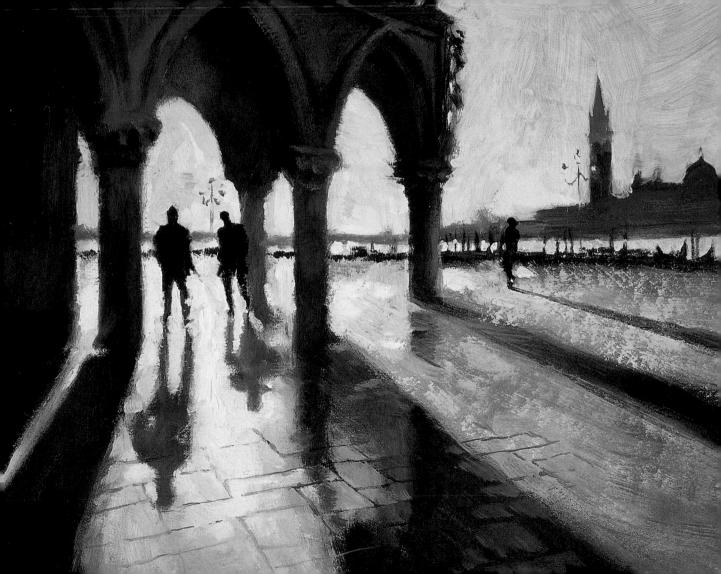

Touching on texture

... the surface ... should transmit to the beholder the sensation which possessed the artist. Sisley

> Up to now you have seen that subjects inspire paintings because of certain combinations of composition, colour and tone. Once all the fundamental requirements of the picture plane are met you can think about the surface texture of the painting, how the paint is laid and the techniques to use; in short, the finished 'look' of the painting.

Since texture is part of the process of painting it follows that it is also a rich source of inspiration. Many exciting paintings may originate from the textural qualities of the objects we see, and the surfaces of natural and man-made items.

25 x 36 cm (10 x 14 in), oil on board

First Light

The painted surface

There is something truly satisfying in portraying texture on the painted surface. Whether it is diligently copied or created by textural painting effects, the results bring pleasure to both painter and viewer.

The physical consistency of oil paint and acrylics can be used in a literal or suggestive way. Watercolour, the flattest of mediums, allows a wealth of textural techniques such as dry brush, sponges, wax resist, granulation and salt crystals to create textural illusion and exciting random patinas.

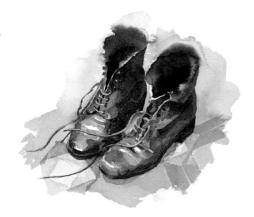

Peeling Paint 18 x 25 cm (7 x 10 in), watercolour

To appreciate textures of details in the landscape it is necessary either to zoom in on them as in this little painting of the back of an old cart, or to use them as close-up foreground features. Here, dry brush and a contrast of tones create the effects of weathering on painted wood.

The influence of time

Fascinating textures are found within bark, rocks, seashores and other natural features. Doors and windows with peeling paint, and stone and wood weathered by the elements, make good subject matter. Have the courage to take a small area and indulge in a simple composition.

The wrinkles and lines of an elderly face and close-up portraits carry a strange weight in any medium, while the hunched figures of old age can portray both wisdom and despair.

To emulate the faded colours of decaying opulence mix complementaries with your colours to dull them a little, and work with a very limited palette to avoid over-coloration.

Fabric textures

Different fabrics with their range of textures and surfaces offer unlimited choice to the artist. The lacy collars painted by Van Dyck and the ethereal organdies of Klimt have brought ceaseless pleasure to the beholder. To utilize the textures of fabrics in paintings try placing them in conjunction with contrasting items. For example, use them as backdrops or tablecloths in simple still lifes. Remember the picture plane likes pattern and repetition, and the flow lines of drapery can be used to bring the eye into a painting, or lead it out.

Before you paint the surface detail, check that the rise and fall of the form of the fabric works effectively in tonal terms.

Foliage

The fine surfaces of leaves and trees provide ever-changing, ever-painted texture. Avoid the temptation to portray foliage as a collection of meaningless daubs; seek instead the main shapes and masses in the trees, bushes or shrubs.

Estepona Pathway 51 x 71 cm (20 x 28 in), oil on paper

To evoke the abundance of colour and growth along this Spanish coastal path the paint is laid in thick daubs with a palette knife. The actual surface texture of the painting becomes as lively as the experience of seeing.

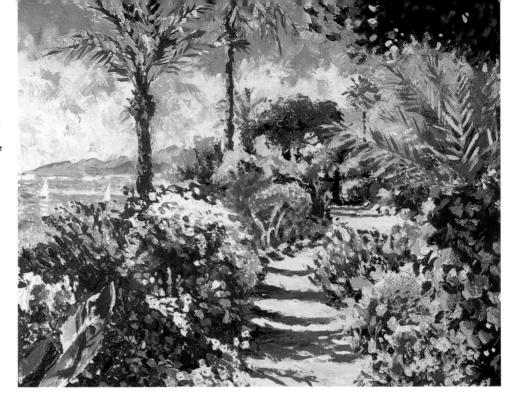

The foliage needs to work as forms first. The whole surface of the painting can be textured or you can suggest texture in a few areas only. Contrast areas of activity with areas of peace. To imply there is abundant texture with a few hints is often more effective than describing every last leaf and twig.

First impressions are usually the liveliest. Beware overworking your painting. Freshness cannot survive a belated search for unnecessary detail.

PROJECT

Creating textures

Rocks and stones provide endless fascination when it comes to exploring texture.

Since the forms are irregular no-one can tell you their shape is wrong. Once you have established the solidity of the stones with tone you can have fun with their surfaces. Try out some of the techniques on these pages and apply them to other subjects too.

watercolour oil on canvas

SPONGING

Using a natural sponge to press the watercolour onto the paper paints a wonderful, slightly random, mottled patina that is perfect for granite rocks. Mix plenty of creamy liquid paint before you start as the sponge will absorb the paint rapidly from the pool in the palette.

SALT CRYSTALS

If you drop salt crystals into pools of watercolour paint the absorption of the pigment by the crystals creates exquisite circular and star-shaped patterns like the patterns of lichen on rocks. The paint takes a long time to dry, so be careful not to brush the salt off too soon.

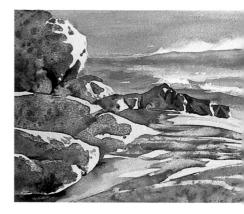

CLINGFILM

The texture in this painting is produced by laying clingfilm over the wet watercolour paint and lifting it off when dry. I find there is little control over the results. so be prepared for a few disasters among your many successes!

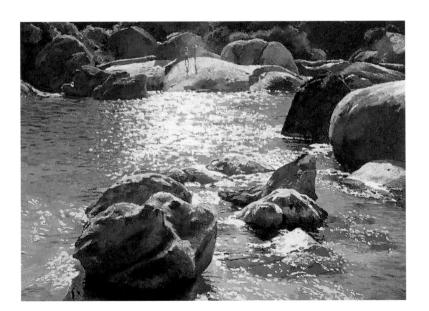

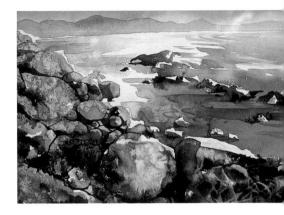

PHYSICAL TEXTURE

The sparkly water among the rocks has a prominent texture. A palette knife is used to apply white oil paint in clean daubs for the light on the water, and then smeared and scraped over the rocks.

postscript

Textural effects become an inspiration in themselves. Exploit them in more abstract ways as well.

Gallery

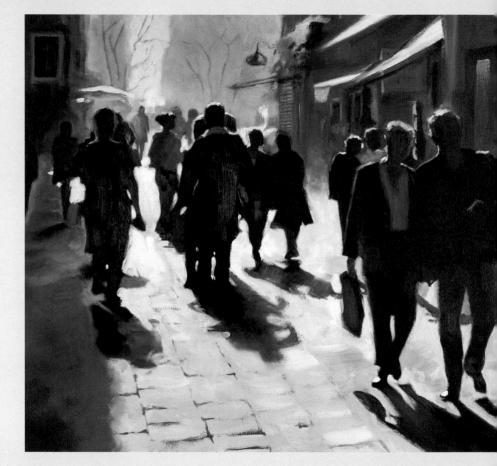

Venetian Passage 61 x 91 cm (24 x 36 in), oil on canvas Looking into the light along a busy street provides interesting shapes, both positive and negative, and dramatic contrasts of tone.

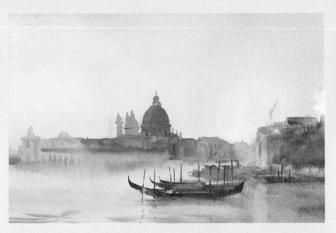

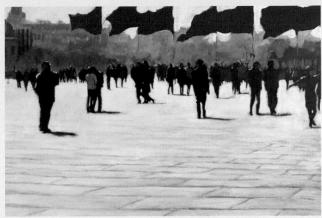

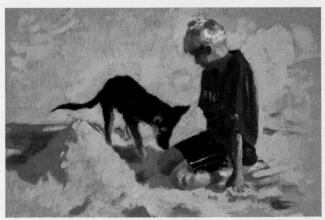

Above Left: Dusky Lagoon 25 x 41 cm (10 x 16 in), watercolour The rising mist in Venice has been an inspiration to artists for centuries.

Above Right: Tiananmen Square 56 x 76 cm (22 x 30 in), acrylic on canvas The fluttering red flags and the stark figures against the dazzle of the square make an exciting combination for a painting.

Left: Sean and Yassen 20 x 28 cm (8 x 11 in), oil on board The tenderness shown between my son and his puppy were the catalyst for this painting.

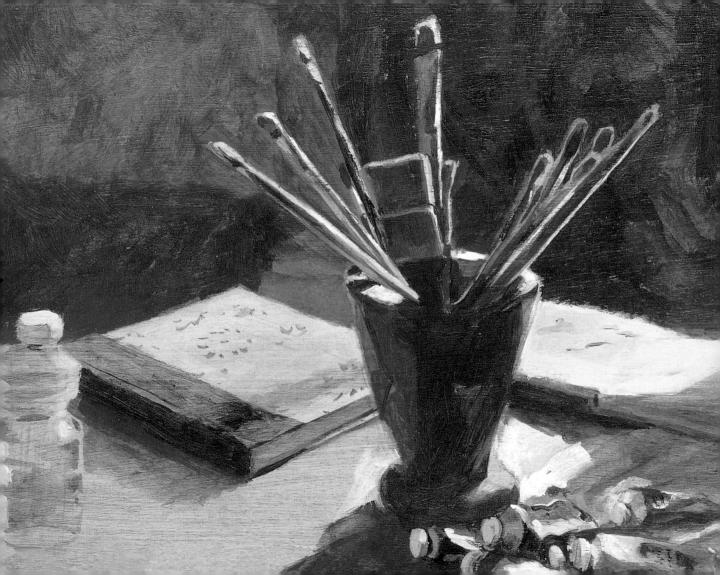

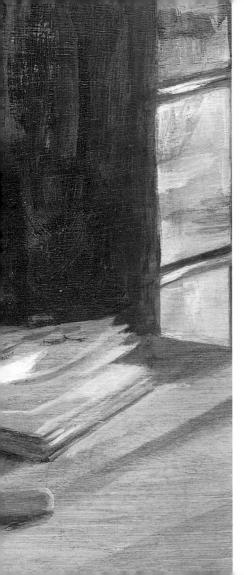

Tools of the Trade

This section is more a checklist on materials and techniques than a list of requirements. It assumes you already own some painting equipment, and suggests tools and surfaces and ways to employ them that might expand your repertoire.

Painters do not need vast amounts of equipment. Over time you will gather more brushes and paint, but probably you will find, as with most things in life, that the items you use most often are actually quite few in number.

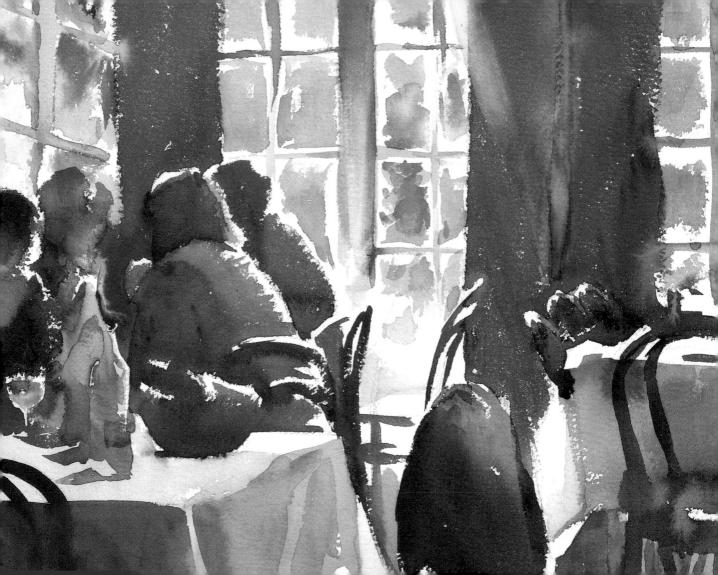

Well equipped

I like painting on a square because you don't have to decide whether it should be longer or shorter... Warhol

Among Friends 53 x 36 cm (21 x 14 in), watercolour

There is no point setting out on an adventure improperly equipped, so now that we have honed the eye let us check out the practical elements needed on this exciting visual journey.

Watercolour paints and brushes

I often find people reach better results mixing watercolour paint from tubes than from pans, especially if they require large amounts of colour. Another benefit is that it prevents you using too many colours in one painting, which is easily done if the colours are inviting you from the palette!

Many aspiring watercolourists work with brushes that are too small. Maybe they think this gives them more control,

but this is not true. Any round, pure sable brush, size 7-12, with a good tip, can achieve broad brushstrokes for washes and fine lines for details. Fiddling with small brushes denies the watercolour its liveliness and encourages overpainting.

The success of watercolour painting lies in knowing how much water to use with the pigment. No one can teach you this; it is gleaned through practice alone.

Acrylic and oil paints

In consistency oils and acrylics are similar and both give a range of texture, opacity and transparency. Acrylics dry quickly and can be readily overpainted, but oils can be manipulated for longer. Both acrylics and oils can be used as transparent tints.

Clean paint is dependent on deciding on the colour and mixing the pigments on the palette before applying them to the canvas. To keep this freshness you need to use several different brushes at a time and rinse any brushes in turpentine from a continually refreshed jar.

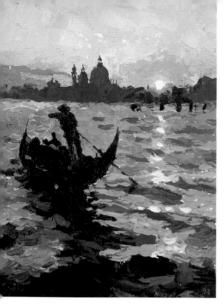

Additional media and tools

The stickiness of oils and acrylics enables you to mix textures into the paint before it dries. Sand or powdered pigment is particularly good for real texture and marble dust for luminescence. Nowadays there are also plenty of tubs for sale that contain readymade gels and stucco that can be added to the paint.

Any type of paint can be applied with natural sponges. Paint can be dripped

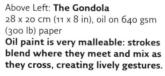

Left: Rendezvous 8 x 10 cm (3 x 4 in), gouache on driftwood A piece of driftwood was a handy surface for this sketch of penguins coming ashore.

from containers, flicked from brushes. spattered from toothbrushes, rinsed off with a tap or rubbed off with a rag to make different textures or effect corrections. Adding pen and black ink to watercolour has a graphic quality and strengthens a weak picture. Coloured inks contribute vibrant and rich textures to the painted image and pastel laid over weak transparent washes of watercolour restores vibrancy.

Texture can be scraped or pressed into all media with knives, combs, fabrics and other tools or objects.

Surfaces and grounds

Some subjects seem to demand certain surfaces, sizes and shapes, and as the ground will also determine the look of the painting it may in turn influence the subject that you choose to paint.

Deciding the proportion of your picture surface is a prerequisite for composition. This will influence the way you see your subject and how you choose the elements to include in your painting.

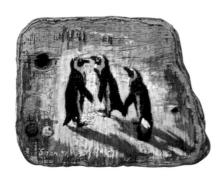

Dreaming

56 x 76 cm (22 x 30 in), oil laid with palette knife on canvas

To avoid muddy turps try painting with a palette knife. Broad flat washes can be scraped on and off, patches of paint laid and even small details are possible. To clean, simply wipe the knife with a rag!

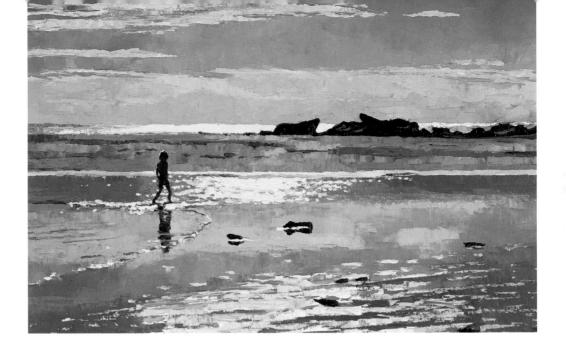

Paper

Paper comes in many thicknesses and textures and can be used for watercolour. acrylic and, if primed, oils too. It can be cut to any proportion at any stage in painting.

Watercolour on paper

Watercolour causes thin papers to buckle, so it is necessary either to stretch the

paper prior to use or to tape it down securely on all sides. Heavy papers, however, do not buckle from wet washes and the thickest - 640 gsm (300 lb) or more - do not require stretching. For outside work sketchblocks in which the paper is stuck down at the edges to prevent buckling are really useful as the page cannot be blown by the wind.

Oils and acrylics on paper

The oil from oil paint will seep out into unprimed paper and probably rot it with time. An acrylic primer over the paper or a couple of thin washes of acrylic paint will prevent this and make a good surface to paint on. The paint dries quicker on paper than on canvas.

Acrylics can be painted straight onto paper, but to avoid the paint being absorbed by the paper prime it with a thin wash of acrylic paint, acrylic primer or emulsion paint. You can also create a coloured ground in this way.

Tinted papers

With watercolour you are not limited to white paper. The radiance of the transparent colours looks richest on a white ground, but you can also paint on tinted papers, or over white paper tinted with a coloured wash. With the addition of opaque white watercolour or gouache you can use darker grounds. Utilize the buff-coloured card at the back of the sketchbook, or try brown wrapping paper.

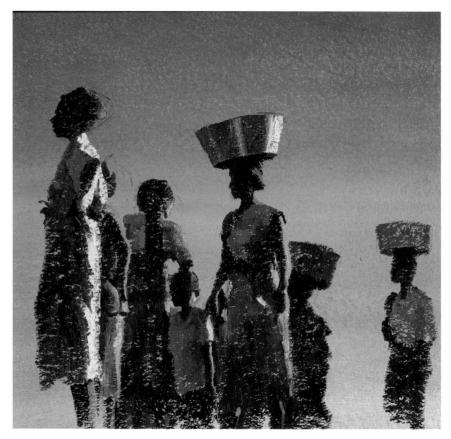

The Catch 46 x 56 cm (18 x 22 in), oil on handmade paper This highly textured paper was primed with pale blue acrylic paint, and the increased weight of the paper gave it substance.

Right: Mud. Glorious Mud 41 x 43 cm (16 x 17 in), oil on hessian Black and white oil paint on unprimed and frayed hessian create an entertaining picture of hippos coming down to water.

Above: Painting Miniatures 25 x 18 cm (10 x 7 in), watercolour and gouache on black card Deep black mounting board was the perfect ground to bring out the luminosity of night-time luxuries.

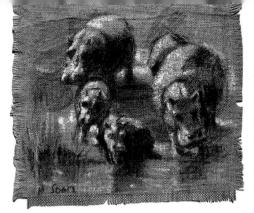

Unusual papers

Nowadays there is a vast array of handmade papers with numerous textures and interesting tints. Experiment on these and you may find some suit you better than others. Heavy texture will certainly challenge the way you lay paint.

If you find yourself without paper turn to the back of hotel bills, old newspapers, brochures and disposable menus.

Canvas

The flexible size and textures of canvas make it a favoured surface for oils and acrylics. Canvas is highly absorbent and ideally should be sized and primed before painting with oils. However, if you wish to

paint with stains of oil colour that you want to run and blend in the fabric only a light sizing is preferable. Acrylics will not rot canvas, so you can use it unprimed, and staining with these is safer fumewise!

Other grounds

Wood is a lovely surface to paint on with oils, having grain and being rigid. Marine ply is a lighter, non-bowing alternative and provides a good unvielding surface.

Oils and acrylics adhere to most surfaces; you can paint on hardboard, plaster, walls, stones, driftwood or fabrics.

I also enjoy painting oils on the backing boards of sketchbooks. A ground tinted with a mid tone frees you from the fear of having to cover all that blank canvas. If, however, the mid tones are already in place, painting the darks and adding the highlights at the outset will quickly give you the essence of the painting. You can tint the ground yourself; earth colours make an excellent base, but you can work on reds, blues, siennas, greys, or any other colour and achieve exciting results.

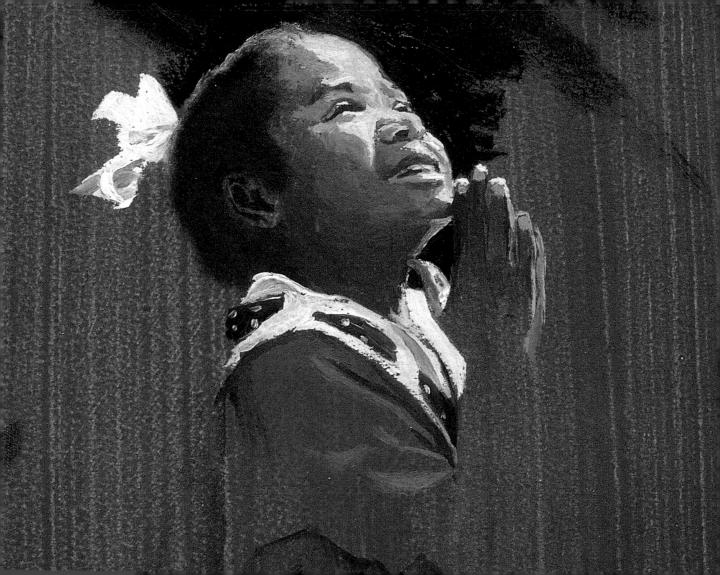

What medium shall I use?

The artist does not draw what he sees. but what he must make others see. Degas

> The vast array of materials open to the painter today makes choosing the right medium for a painting very exciting, but also more difficult. Any subject can be painted with any medium, and different media, with their diverse applications, require a different approach to the source of inspiration.

Neither should limitation of means be considered a disadvantage; improvisation stretches the creative muscles and engenders new ideas.

Give Us This Day (detail) 30 x 23 cm (12 x 9 in), watercolour

Fitting the purpose

Sometimes paintings are simply records of our visual world or the response to visual stimuli. At other times we are deeply touched and want to convey to others the sincerity of that emotion. Imagination in art lies in finding the most complete expression. Choosing the right conveyance is as important as seeing the shapes, colours, lines and tones that inspire the painting.

There are no rules about medium preference: practice and personal choice will dictate. Follow your inclinations and you will find your own milieu.

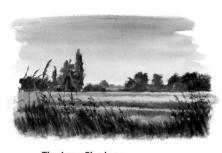

The Long Shadows 25 x 41 cm (10 x 16 in), acrylic on paper For quick landscapes acrylics are very versatile. Here they have been painted in thin glazes for the sky, trees and field, and then used more thickly to build up the grasses in the foreground. Pale opaque yellows have been used to retrieve lights lost in the haste of painting.

Choosing a medium

Speed of application can determine your choice. Watercolours can be swiftly painted and can quickly render transient subjects, such as skies, and movement. They are light to carry and clean to use. and require easily available water, so are ideal for the travelling artist or for someone with limited space to work. If you are seeking speed, radiance and spontaneity watercolours are a good choice.

When it comes to texture there is far more versatility with oils and acrylics. In some respects these paints are more forgiving than watercolour because they can be easily reworked. In opaque media you can work from dark to light, which confers a rich density on the painting. Some subjects require a stronger 'look'; strong contrasts and three-dimensional forms welcome depth.

The factor of scale

Scale, too, can determine your choice. Paper in very large sizes is unwieldy, so if you choose to work large, canvas, wood

or board are the likely surface and will affect the medium you use. Contrasts of light work well in smallish watercolours. but to paint the same subject on a bigger scale would require so much paint for the dark areas that it is easier to use oils

Because of their opacity and consequent visual strength oil paintings are clearer to appreciate from a distance. whereas the subtle qualities of watercolours welcome closer inspection.

Transparency, glazing and tints

As well as mixing colours on the palette. watercolours, oils and acrylics can all be laid in successive tints of transparent colour. Watercolour painting is all about laying coloured tints one over another; in acrylics and oils too you can enliven a colour by overlaying or glazing with a hue of similar temperature. You can also dull down colours and increase or decrease contrast between adjacent hues by using complementaries. Garish colours can be calmed down simply by overlaying a tint of the complementary colour.

Below: Gather the Dawn 56 x 76 cm (22 x 30 in), oil on paper I made several small sketches of the fishermen at dawn in watercolour, but when it came to painting a larger piece I could only imagine it in oils. The strong contrast of silhouettes with dazzling dawn light and the timehonoured simplicity of drawing in the nets somehow required the opacity of oils.

Improvisation

The beauty of painting is that there is nothing you cannot paint, and nothing you cannot paint with. There is no real reason to be concerned with the longevity of the painting, so experiment with any media on any ground.

Surprise yourself by working with unfamiliar media. Quite quickly you will find your own preference and scale; you will be irritated with one method and delighted with another.

Remember you are not even limited to conventional pigments and art materials. I have resorted to using coffee in place of Burnt Sienna and have painted on newspapers and shopping or café bills when no paper is at hand!

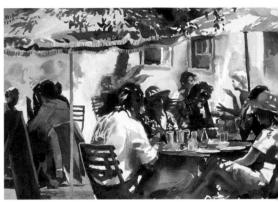

Above: Café, Church Street 43 x 64 cm (17 x 25 in), watercolour The dancing, radiant sunlight and moving people made watercolour my first choice for this painting. The same subject painted in oils or acrylics could look just as sunny, but it would have a different 'feel'.

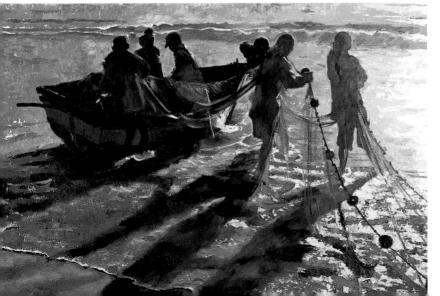

Experiments with media

One way to provoke inspiration is to experiment with different or less familiar media combinations. This can also include painting over unsuccessful, discarded pictures. By recycling failed paintings you not only save waste, but gain the freedom of working on a surface that no longer holds the fear of 'the new', 'the expensive' and 'the precious'.

MATERIALS USED Quink ink oil paint acrylic primer paper wood

OIL OR ACRYLIC ON IUNK WOOD PANELS Junk wood door panels from old cupboards and cabinets make an excellent surface for oils, with the added benefit of a 'frame'. Oil paint can be painted straight onto the wood, even if it is grubby or stained. If you use acrylic, de-grease the surface with a mild detergent to enable the paint to adhere. In this scene the split in the wood is used as the horizon and the grain breaks up the brushstrokes. Instant inspiration!

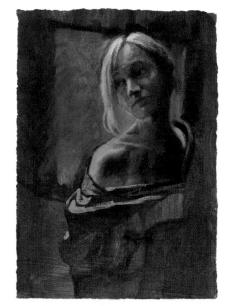

OILS ON WATERCOLOUR PAPER

An unsuccessful watercolour can be over painted with an acrylic primer and reused for an oil painting. Here the paper is torn along the edge of a ruler (from the back) to make a deckle edge, and stained with thinly brushed layers of diluted Burnt Sienna acrylic to tint the surface. The texture of the paper, and even sections of the underlying picture, remain visible under the new painting, enhancing the surface interest of the fresh image. The sketch can be float mounted to show off the deckle edge.

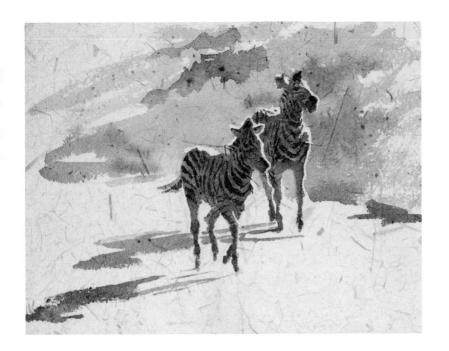

OUINK INK

Black Quink ink is a delightful and surprising medium. When diluted the ink pales through indigo to blue and the constituent yellow or magenta dyes in the ink seep out giving subtle tints to a monochrome sketch. The zebras' stripes are painted with undiluted ink.

postscript

Visit exhibitions of work in different media. Other artists' ideas will revive your own and inspire new ones.

Gallery

Right: Red Studio 61 x 91 cm (24 x 36 in), acrylic on canvas The paraphernalia of the artist's studio makes a great subject for a colourful painting. If you are short on inspiration, paint your brushes and paints.

Centre: Red Sarong 36 x 25 cm (14 x 10 in), watercolour Red and turquoise are opposites on the colour circle; using these two colours together creates vibrant contrast.

Far Right: 'Where Are You Going? Where Have You Come From?' 76 x 56 cm (30 x 22 in), oil on canvas Although this is a figurative painting, the aerial view abstracts the image and so makes an interesting composition.

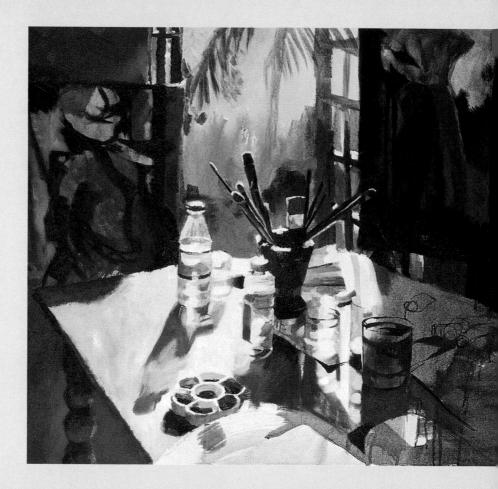

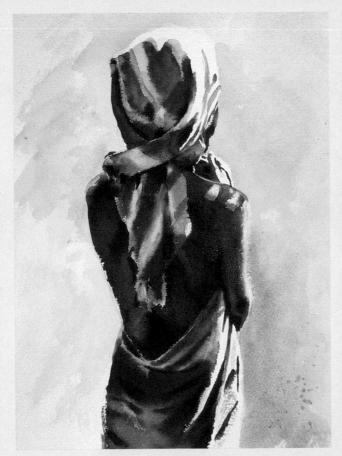

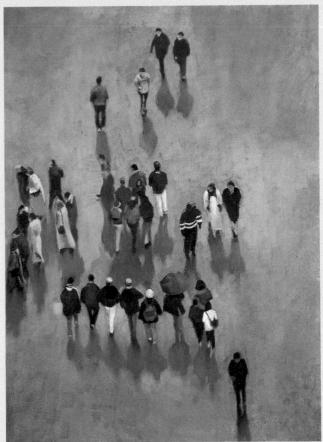

The Adventure of Painting

In the following pages you will see that inspiration for the artist is everywhere; there is so much material out there just asking to be painted. Trust your instincts, and experiment. Be prepared to cover canvas and squeeze paint. Do not be fooled by the predictable, nor ignore the mundane. Work small, work large, paint slow, paint fast. Try not to judge the results too early. Treat your painting as an adventure and involve your whole being in every moment.

The environment is the composition.

Kandinsky

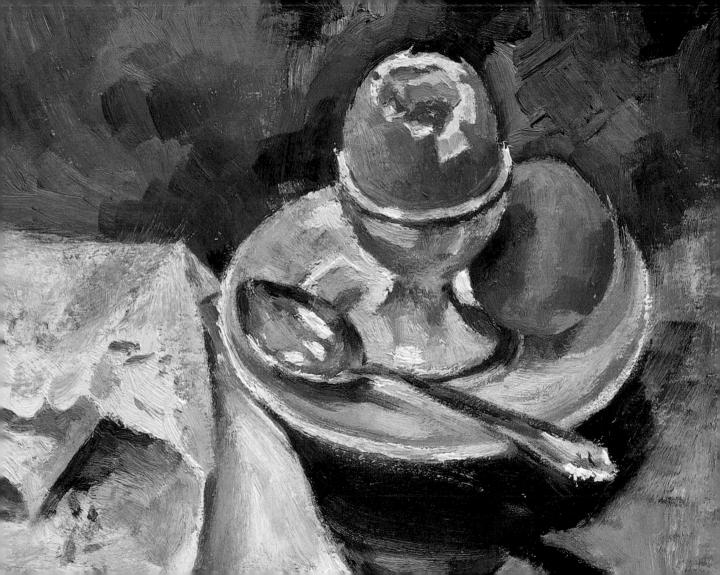

Inspiration at home

To paint ... paint ... without being afraid of painting badly ...

The easiest place to pick up a paintbrush is in the comfort of your own home, out in the garden or the patio. Still-life, figure and interior subjects abound, and some of the best subjects are the least obvious. Before you clear the table check it out for potential pictures, or make the most of the children sitting still watching TV!

Potential paintings

Look around, just sitting where you are. Remember all the things a good painting needs - interesting shapes, contrasting colours, differing tones. Half close your eyes; a play of tones is easier to see once colour is excluded. Home in on small details - the corner of a newspaper, a

cup, or the light on a bottle or glass. If you cannot find anything to excite you widen your view a little, and move your vision left and right, up and down.

Interesting things

The joy of painting objects that sit still is the chance to really look at all the little innuendos of tone and colour, and interpret them in paint. Overlapping objects in the composition makes it easier to suggest space. Try to paint with the whole picture in mind to avoid leaving isolated items. You do not have to be too ambitious; a fragment painted well is better than a whole picture painted badly. The painting does not even have to be finished to be interesting.

Light falling from, or seen through, windows is an excellent place to find potential paintings. Table tops and surfaces lit from behind carry a wonderful sheen and offer reflections and deep shadows. The precise details of an object seen against the light will dissolve away when you half close your eyes.

Born with a Silver Spoon (detail) 28 x 18 cm (11 x 11 in), oil on board

Family and friends

At home someone around you will either sit still long enough to give you a chance to paint them, or you will become very good at quick sketches! The essence of movement, even in the still figure, is an important way of breathing life into your figures. Brushstrokes with a dance in their step, blurred passages of colour. even slight inaccuracies in drawing or elongated proportion, all add life to paintings of people. You do not need to overload faces with detail, nor even worry too much about likeness

If someone is sitting in a chair or lying on a bed, blend their shaded side into the fabric of the support so that they rest in it and are not separate from it.

Faces and features

Painting faces is always challenging and fascinating. Take the risk; it does not really matter if you cannot catch an exact likeness. The shared joy of painting and being painted is easily worth what is sometimes the worst of end results

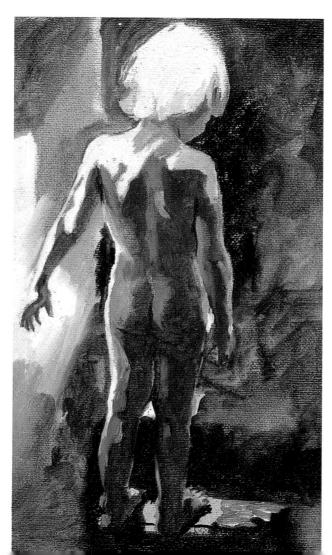

Stepping Out 20 x 15 cm (8 x 6 in). oil on canvas Children change so fast that any painting of a moment caught in time will be treasured later. Back views are often more telling than front views as the shape of the person and their pose identifies their character without the facial features demanding attention.

Above: The Sarong 25 x 18 cm (10 x 7 in), watercolour In this gentle sketch of my sister, Mary, the colour of the sarong is run into the folds of the bed linen to 'sit' the figure into the soft fabric.

Right: Louis and Oopa 13 x 18 cm (5 x 7 in), watercolour This portrait of grandfather and grandson is painted into the light and simplified into two tones - light and dark. Burnt Sienna was washed over the whole paper and then Sepia and Burnt Sienna mixed together for the dark tone. Even with such simplicity much is said about their relationship.

Keep it in proportion

Look at the proportion and shape of the overall head and hair, and the positions of the features of the face in relation to each other. A person's likeness or character is held just as much within these proportions as in the features themselves.

A portrait does not have to be head on, or head and shoulders. The face can be almost hidden behind hair or hands, or

wreathed in darkness. You can paint just the eyes, just the mouth or even the hands on their own. A face can be blown up to enormous proportions, painted with unnatural colours or painted and scraped off to form a blur. There are no rules. even in portraiture.

And there is always the mirror. Here you will be able to paint and draw the most sympathetic model of all!

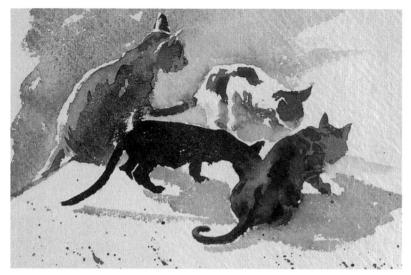

Above: Cats on the Scrounge 13 x 18 cm (5 x 7 in), watercolour To paint the irregular patterns of fur touch the stripes or patches of colour into wet washes so that the colours merge softly.

Right: The Potting Shed 10 x 8 cm (4 x 3 in), watercolour An untidy corner of the garden can prove interesting for a quick sketch. The delicious blends of watercolour washes almost romanticize this scruffy subject.

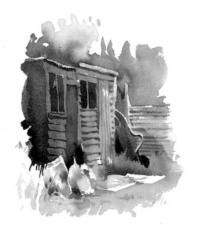

Animals around

Cats and dogs and other beloved pets make wonderful, if not always obliging, subject matter. My favoured medium is watercolour, where the natural blends of wet-in-wet washes create the patterns of hair and fur almost by default. Take care not to make the animals look too static.

Charcoal or brush and ink drawings of elegant felines make excellent studies and are a great way to learn how cats move and to see the shapes they make. Swift fluid brushstrokes make it easier to catch the walking motion of dogs than drawing with a pencil. The lovely tangle of legs of resting and sleeping animals is always a joy to paint; note the positions quickly before they roll over or change to another great pose.

Right: Monday Morning Reds 30 x 20 cm (12 x 8 in), watercolour

Trust your instincts; telling someone you have just been painting the washing on the line may sound odd, but for the painter there is as much interest to be found in the changing colours of a curling cloth as there is in a complex interior.

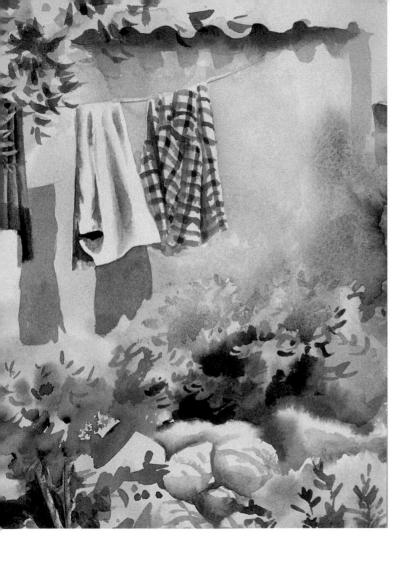

Your own backyard

Outside in the garden or on the balcony you will find an inexhaustible supply of mini landscapes and still lifes. A single flower or sprig of leaves, a broken branch or cracked flowerpot vie for equal attention with flower borders and leafy bowers. My interest is always drawn to bags of compost, watering cans and broken fences, especially if lit by the sun. Weather-worn discarded items hold as much charm as the lovingly tended displays of flowerpots and window boxes.

Look for tonal interplay, fascinating shapes and interaction of colour. Check that your chosen subject has a focal point, a main point of interest; give extra attention to that in making the painting.

Prime time

The chief delight of painting at home is the ease it bestows on your painting time. You can work at your own pace, in privacy. Take advantage of this, even if you can spare only an hour; it will be an hour well spent, and well rewarded.

DEMONSTRATION IN OIL

Green Apples

Ordinary items make great subjects. The spherical forms of apples offer shiny highlights on their surfaces and intriguing dark corners where they meet and overlap. Add to that the dominant stripes of a tea towel and the subtle tonal changes on a brown paper bag and you have a satisfying couple of hours' painting ahead of you!

COLOURS

Prussian Blue
Titanium White
Rowney Yellow
Indian Yellow
Sap Green
French Ultramarine
Raw Umber
Burnt Sienna

- 1 I spilled the fruit onto the folded cloth and made a satisfying arrangement. Then I studied the colours and tones, and took from my paintbox the colours I wanted. I sketched out the main shapes on mid-tone buff-grey board using dilute Prussian Blue, looking for flow lines and cross referencing. Next I marked in the highlights and dark corners.
- 2 I followed the flow of the stripes with dark Prussian Blue to create the folded fabric. Then, starting from the middle, I began to paint the apples and paper bag as different tones and colours joining up across the picture plane. By using a mid-tone ground the three-dimensional forms quickly took shape, with lights and darks emphasized.
- 3 I noticed how the greens changed from blue-greens to yellow-greens, and translated that into the paint mixes. I changed the colour on my brush constantly as I painted the apples, dipping in and out of several different greens. The same process applied to the varying browns of the paper bag.

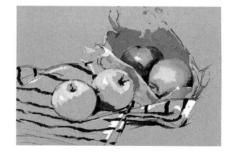

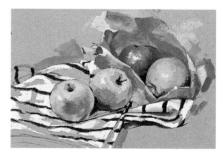

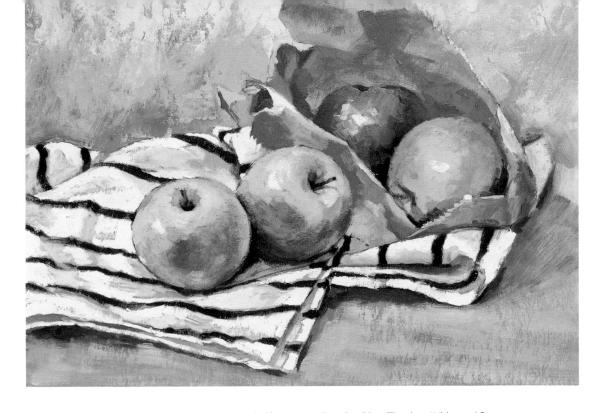

4 The shadows on the cloth were half supplied by the buff board colour, so I simply spread thin washes of dilute white between the highlit areas to soften the shadows in between. I half closed my eyes to assess the background tone and brushed in a mixture of

Prussian Blue, Titanium White and Raw Umber with bigger, flatter brushes and a palette knife. The colour on the table was dragged across roughly to retain the energy of the brushstrokes. Careful colour mixing avoided overpainting, and muddiness.

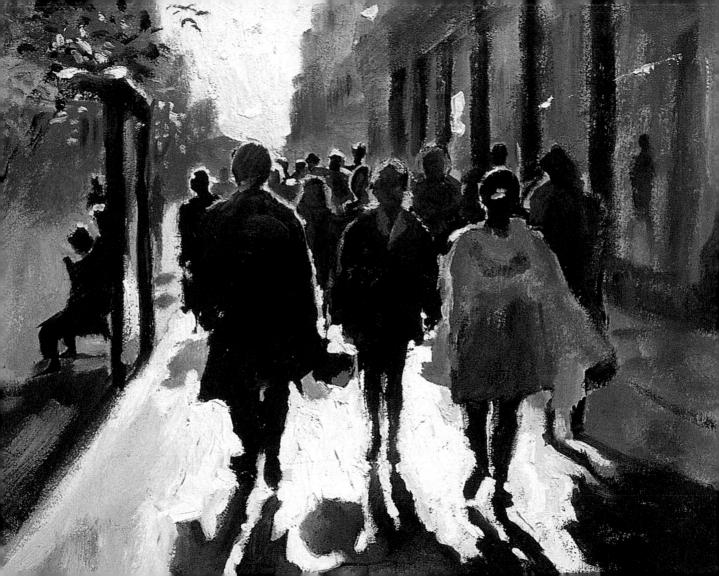

Inspiration about town

One must not imitate what one wants to create.

Outside the shelter of home a wealth of subject matter awaits. The urban environment seethes with painting ideas, limited only by your imagination and lack of access beyond your control. If you have not painted outside before, or in areas populated by curious onlookers, you may need to pluck up courage, but do not let fear of what others may think prevent you from enjoying such a bounty of subjects.

Visual surprises

Townscapes are about man and his creations, on his scale. Sometimes they are magnificent, sometimes awful. But light can turn an ugly scene into a

glorious panorama: write nothing off as an improbable subject. Be prepared to be surprised. Trust your own judgement; if something has kindled your interest it is a worthy subject for your brush.

Weather may greatly influence the choice of subject. On a sunny day the three-dimensional forms of buildings and the strong cast shadows will stand out. On grey days the view will be tonally flatter and inspiration will depend on receding tones and moving activities. Rain offers fascinating reflections, with the added bonus of repetition of the image above and below the ground line.

Rush Hour. Oxford Street (detail) 30 x 23 cm (12 x 9 in), oil on board

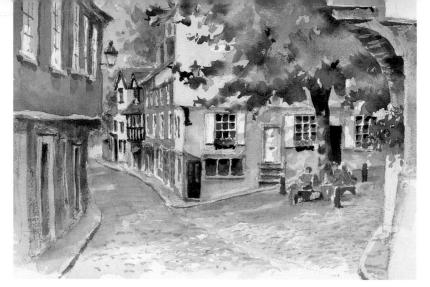

Elm Hill, Norwich 25 x 36 cm (10 x 14 in), watercolour The perpendicular space between the two sides of the narrow road interested me. I liked the way the thin space opened into a courtyard and was narrowed again by the building on the right. I chose my composition through a viewfinder and started from a middle point - the left-hand white shutter.

Street life sketches

Start by making quick drawings in a sketchbook; that way you will not feel so exposed, and you can perch on any railing or lean against any wall without having to find the perfect spot to lay out all your paints. A small palette, a size 6 sable brush and some water are all you need to make colourful sketches, or just use a pen, felt-tip, or pencil.

Always make it easy on yourself rather than awkward. Stop along the street, or

sketch in cafés; sketch buildings, people shopping, chatting over coffee. Pull out your sketchbook on the bus or train or while waiting in a queue. Some people will notice and be curious; if so just smile or look away casually and pretend you are painting someone or somewhere else. It feels like espionage and is all the more exciting because of it!

Setting up the easel

Once you feel at home with sketching you can be more ambitious. Limit your materials to the essentials and if you are setting up an easel and stool think about the main passage of people before you choose your site. Being 'in the way' will break your concentration and your view will often be blocked. I usually work with the sketchbook on my knee. If you feel embarrassed place a finished copy of a painting beside you so passers-by realize your current work is still in progress.

Use your viewfinder to determine the composition, and step back from your sketch to check it works.

Above: Passing the Time 28 x 20 cm (11 x 8 in), black and white acrylic on back of sketchbook

Even painting in the rain can be fun. Find some shelter and enjoy the reflections in the wet paving stones. Architecture does not have to be painted accurately to feel durable.

Right: Oueens Mall. Milton Keynes 41 x 51 cm (16 x 20 in), watercolour

The abstract patterns and geometric shapes of modern glass architecture are a fascinating subject. especially painting reflections in watercolour. Here the clouds are reinvented right across the front of the building.

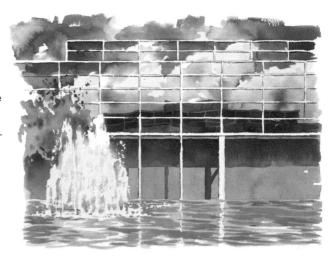

Buildings

The linear characteristics of urban buildings offer some interesting design ideas. You can take a perspective view along a street, or paint a façade head on, or look up at rooflines and chimneys.

A strong light source makes it easier to create solidity as you change the tone on the different angles of buildings, and lightening the tones of your buildings as they recede will create a sense of space and distance. Alter the view to suit your

composition. Lowering the height of buildings and reducing the number of windows is within the artist's power!

Shops with window displays and the darkness found under awnings create delicious dark tones. For reflections on glass vary the tone in the glass between the areas of reflected light on the surface and darker areas within. In oil and acrylic, and even in watercolour, you can lay a glaze of dilute white (or pale blue) over dried paint to suggest reflected light.

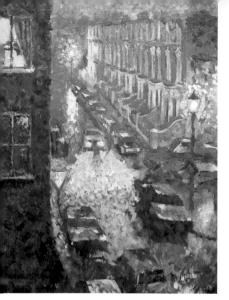

Parking Problems in Edith Terrace 122 x 76 cm (48 x 30 in). oil on canvas

The view from my studio window in Chelsea had long attracted me. and finally one wet night I could wait no longer. Contrasting purple and yellow, and using lively dabs of colour, I brought my mundane fascination to life.

Vehicles

A bicycle always makes a good subject. leaning against a railing or propped by a wall, but cars, too, are fun to paint. There is always charm in the mundane; never ignore the images of your own urgent time. Impressionist paintings look nostalgic to us now, but they were thoroughly modern when painted.

Bright yellow and orange construction vehicles make great shapes, and cranes look exquisite against the sky. Commercial vehicles, such as the vellow New York taxis and black London cabs or red buses, tell you the location of a painting without the addition of any of the tourist sites. Even road signs and lettering can be fun to paint, or can brighten up a dull picture.

Painting figures

If you are including people in your painting vary the poses and colours. The overall shape of the figure counts, not what happens within it. There is usually no need to define feet and hands, nor

faces, too clearly as this can tend to make the figure static; an indication or suggestion is enough.

Advancing or retreating figures can be indicated by simply showing one leg shorter than the other to suggest walking. If a figure is leaning unsupported the ankle carrying the weight will be in a line beneath the nape of the neck.

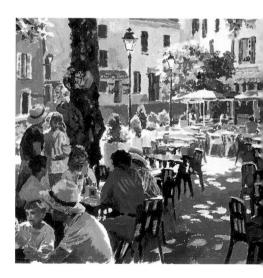

Right: Multitude 13 x 18 cm (5 x 7 in), watercolour

See how little detail is included in this throng of people. The numerous haloes of light and dark blobs for bodies denote a crowd that is barely painted and yet you know is there.

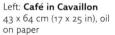

Planning the composition is even more important if much is happening in your picture. Here the aisle between the tables leads the eye through the dappled shade into the light beyond. Although the people are to the lefthand side they remain the focus of the painting.

Urban Activity

Crowds and groups of people in urban settings seem overwhelming at first, yet it is less difficult to portray figures en masse than to paint individuals: a few colourful

blobs and lines will quickly render a throng of people. In any situation of intense activity pick out only that which interests you and either give it dominance in the foreground or just leave out the rest.

The mood on the streets

Depending on the weather, the locale and the time of day, urban settings can change tremendously. A building site or industrial sprawl may look dull in daytime, but is transformed at sunset: scaffolds, cranes and pylons turn into graceful silhouettes. The steam from cooling towers and the smoke from chimneys may not help the environment at large, but they create marvellous atmospheric scenes.

Use the properties of colour and tone to evoke and enhance the mood you want to convey: light, bright colours for an upbeat ambience, cool, dark colours for a serious note.

Alternative viewpoint

Looking at things from different angles can be the catalyst for a painting. Looking down onto a view removes the necessity for a horizon level. The flattening of the perspective on the picture plane suggests a more abstract quality to the composition and long shadows are very dramatic.

School's Out 25 x 30 cm (10 x 12 in), acrylic on board The temperature of colour can create atmosphere. In this painting the blues and whites evoke the chill of winter and the reds invite the cosy warmth of the children dressed against the cold.

Pigeon in St Mark's Square, acqua alto 28 x 20 cm (11 x 8 in). oil on canvas

This viewpoint is at ground level, looking down at the reflections of the people crossing the catwalks laid out in the piazza when the water is high. Without the pigeon the composition remains obscure

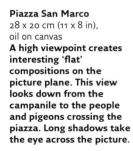

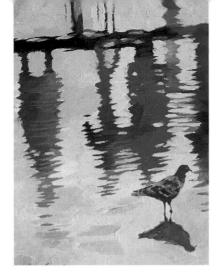

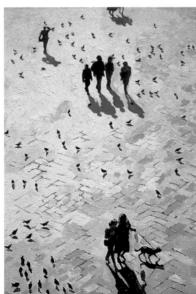

Do not forget to look up too! You will see the patterns of urban skylines, the corners of buildings, chimney pots and tree tops, all starkly edged against the changing colour of the sky.

A wealth of grevs

On damp overcast days the urban landscape can look devoid of colour, almost grev, but for the painter this is another opportunity. Mixing the three primary colours together (or two complementary colours), creates greys, browns and blacks. In oils and acrylics these can be lightened with white to create any tone, and in watercolour simply use water to dilute them.

The loveliest greys are made by mixing together colours that are not pure primaries, but between them hold some red, yellow and blue: try Burnt Sienna and French Ultramarine, or Alizarin Crimson and Viridian. Mixing two colours to make your grey enables you to veer the grey towards a particular colour more easily than if the grey comes from a tube.

DEMONSTRATION IN ACRYLICS

Chimney Pots

Urban skylines buzz with intriguing shapes, patterns, forms and colours. Homing in on some particular roofline feature makes an interesting painting subject. These chimney pots lit by the afternoon sun were several houses away. The strong tonal contrast combined with the distance made it easy for the eye to differentiate between the main shapes. but not get carried away with surface detail

COLOURS

Burnt Sienna Cadmium Red French Ultramarine Raw Sienna Titanium White

- 1 I stained the canvas with a wash of Burnt Sienna, the chimney-pot colour, which gave a general underlying warmth to the painting. Being acrylic, this dried quickly. Onto this coloured ground I drew the outline shape of the roofline with a varying mixture of Cadmium Red and French Ultramarine, and washed in the areas of darkest tone.
- 2 Satisfied with the composition, I darkened the Cadmium Red and French Ultramarine mix and mapped in the dark areas more positively. I brushed in Cadmium Red to blend the dark and lighter sides of the rounded chimney pots. I indicated the brickwork with dilute washes and picked out the highlights with white mixed with a little Raw Sienna.
- 3 With a big flat brush and a mix of French Ultramarine and Titanium White, I brushed in the shapes of the sky between and around the chimney stacks. Where pollution tinted the sky pink I added a touch of Cadmium Red into the mixture. I laid a glaze of Raw Sienna over the brickwork to make it more yellow.

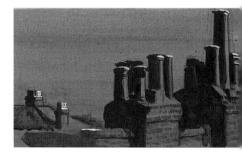

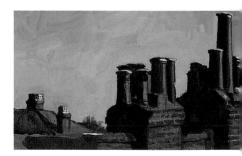

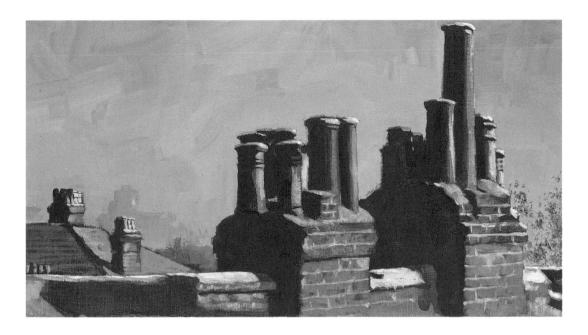

4 With a darker mixture of the red, blue and white, I suggested the hazy distant buildings and introduced the white copings along the roof ridge. At this point I felt that the painting could be finished, but then I decided to add more information. I painted the mortar lines between the brickwork and around the chimney-pot base with a Raw

Sienna and white glaze. Standing back to look at the painting, I thought that the right-hand corner looked empty of life, so I mixed Raw Sienna and French Ultramarine into a rich creamy mixture and, with a natural sponge, patted the colour onto the canvas to form foliage. I then decided the painting was finished.

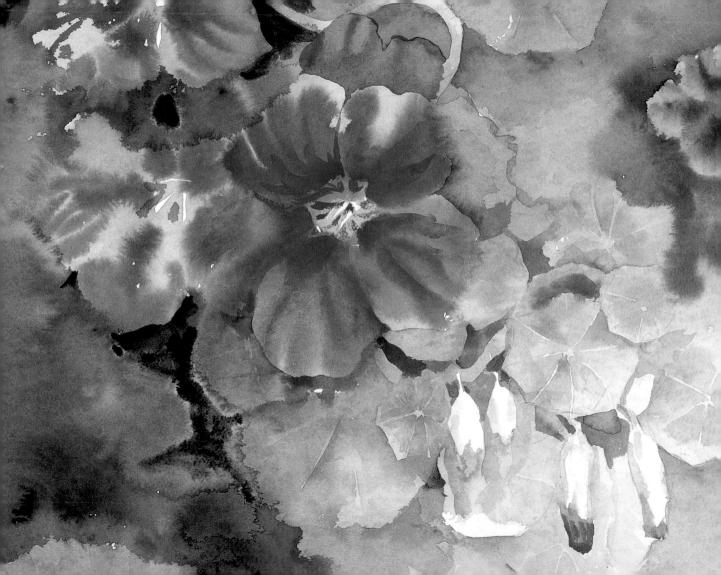

Inspiration in the country

Nature contains the elements of all pictures ... as the keyboard contains the notes of all music.

Whistler

Walking through the countryside we come across potential painting after painting. Divine creation offers endless subjects from vast panoramas to the thrill of a single leaf.

Even where man adds his creation to that of nature the two seem to work in harmony as natural materials such as stone and wood rise upward in walls, fences and farm buildings. Ordered plantations are as charming as untamed woodland, while man-made canals are as fascinating as meandering rivers.

And in addition to all these abundant riches we have the added bonus of changing seasons, where familiar

landscapes are transformed into new and wonderful variations of colour and shape based on a similar theme.

Abundant choice

There is so much to choose from, and usually limited time. First, allow the eyes to roam and wander as you walk or drive through your landscape. Respond to the overall shape of a line of trees or buildings on the horizon. Look for an interesting bend in the road or the pattern of shadows across a track.

Be aware of colours, such as the colour of the fields, one against the other, and the pattern they will make when translated to the paper or canvas.

Details in the landscape

Look down at your feet, up above your head, and into the undergrowth. The patterns on bark, a broken log, a few flowers caught in barbed wire or the doleful eyes of a tethered mule - these little details can be more significant than a classic landscape view.

Landscape Fragment (detail) 56 x 38 cm (22 x 15 in), watercolour

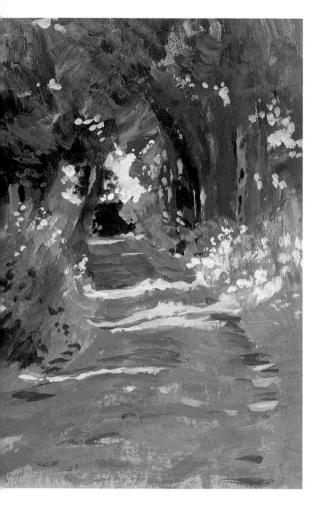

The Track 25 x 18 cm (10 x 7 in), acrylic on board Shadows and lights change really fast on sunny days. Before laying darks all over the painting I marked out the highlights across the path and on the grasses. These became obscured as the painting progressed, but were easy to retrieve with fast-drying acrylic.

Changing light

The movement of the earth around the sun causes continual changes in the direction of the light source from the morning to the afternoon. If the sky is overcast the light tends to be more even, but as most of us prefer to go out painting on a warm sunny day this change in direction has to be addressed. You can, of course, paint several different paintings through the day to prevent you chasing the sun and its shadows.

If you want to work on only one painting you need to apply visual memory, supplemented by sketches; otherwise you may invent an all-day light source that weakens the picture. Mapping in the shadows or areas of darker tone fairly near the start will help, especially in watercolour where tonal changes are hard to alter later in the painting. In oils and acrylics you can retouch whole areas and alter your tones completely, but with oils they will become muddy, so it is still wise to decide on the light direction you will paint at an early stage.

Above left: The Great, Grev. Green, Greasy Limpopo 23 x 30 cm (9 x 12 in), watercolour

Water in a landscape will usually reflect the colour of the sky. but the Limpopo in flood was mud coloured. The ochre-brown of the water and the blue of the sky mixed together made the perfect dull greens for the trees, preserving harmony in the painting.

Above right: Climbing lvy 15 x 10 cm (6 x 4 in), watercolour

In this small detail I found much enjoyment in picking out all the different greens of the foliage, easily seen under an overcast sky.

Dull days

Dull days have their advantages for artists. Not only do they supply a more even light, but the subtle variations in colour, especially among greens, show up more clearly without strong light and shadows to obscure them. Hue rules when there is little tonal contrast. You will notice how reds stand out more on dull days than they do in sunshine.

Whereas a photograph might look dull on a low light day, an artist can see and bring to our attention both colour and tonal difference to make it appear more lively. Even subtle variations in colour and tone are attractive in the painted image.

Enjoy detail

The textures of weathered wood found on gate posts or old barn doors are a wonderful excuse to use textural effects such as wax resist, salt crystals and dry brush in watercolour, and combs and palette knife in oils and acrylics.

Explore the countryside for small details. You do not even need to make a composition: when your eyes alight upon the smallest area of interest indulge yourself in a painting of just that.

Bright sunshine

Before you choose your subject on a sunny day, look in both directions; sometimes the view looking into the sun is more exciting than the obvious sunlit view. The tonal difference between the areas cast in shadow and the dancing highlights can make a livelier painting.

Look at the colour of the shadows and how they link to the objects that cast them. Allow your shadows to run or trickle out from their objects, so that the two are united in colour and tone, not painted as separate items.

Greens

Many landscapes tend to a preponderance of green. In watercolours greens are best mixed from blues and yellows/ochres/siennas, so that even within the mixing slight variations occur. If there are many different greens to be painted it helps to link them with the same blue; that way harmony exists as the blue is common to all the elements.

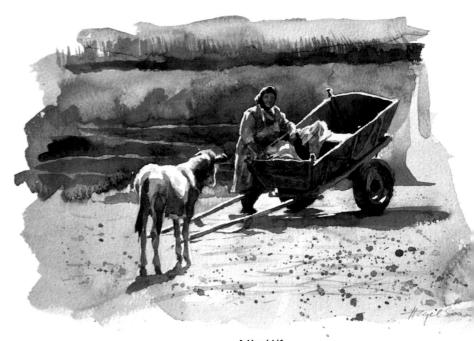

A Hard Life 20 x 28 cm (8 x 11 in), watercolour The calf's legs and the cartwheel connect to their painted shadows.

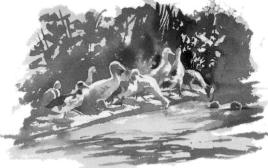

Look Right, Look Left 20 x 28 cm (8 x 11 in), watercolour Prussian Blue, a cooler blue than French Ultramarine, is mixed with the red and yellow and creates a cool shadowy mood.

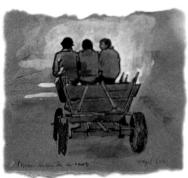

Three Men in a Wagon 15 x 15 cm (6 x 6 in), white gouache and black watercolour on brown paper Simplicity of expression, as in this tonal sketch. is often the best way to paint a touching scene.

In oils I find the most vibrant greens are usually those ready mixed from the tubes. Other colours in the painting can then be added to these greens for darker tones.

View your foliage as forms rather than individual leaves. A flat brush in oils will help you paint your greenery in blocks rather than dabs, and wet-in-wet washes in watercolour will stop you fussing over details. Sponges can also be used to give light foliage a random look.

Atmosphere

Landscapes have atmospheres, often bound together by a predominant colour. For overall warmth, paint with warm colours, reds and oranges, and yellows and blues that yeer towards red. You can

tint your canvas, board or paper with a colour appropriate to the painting. In watercolour this could be a dilute wash over the paper on which you paint subsequent washes, perhaps a warm Yellow Ochre. In acrylics an underwash of Burnt Sienna lends warmth to a picture.

For a cool atmosphere use cool blues and blue-greens, cold yellows, mauves, umbers and greys. Undercolour can again be strong, but pale blues and greys are helpful if there is a large area of light sky.

Since oils and acrylics are opaque it is exciting to build highlights and darks onto a mid tone appropriate to the mood of your painting. You can even use rich dark colours under your painting or use the natural colour of linen canvas.

Skies

The sky above is an integral part of a landscape. Never be afraid of placing colour in the sky, even if it appears almost white. Bring whatever colours you use in the sky into the landscape below to keep sky and land united.

The sky nearer the land is often lighter than the sky above your head. This variation in tone, from lighter up to darker, will give a sense of space and distance to the aerial canopy. A blue sky is often darker in tone than you think, so check it against the lightest areas of the composition, especially those against the sky, such as chimney pots and highlit foliage.

Events

In general people or animals can add life and focus to a painting. Sporting occasions, local fiestas, riding events or fêtes are a rich resource of action if you have the courage to attempt them. Try not to be too ambitious; just enjoy the atmosphere and fill the pages of your sketchbook.

Left: Cumulonimbus 16.5 x 15.5 cm (61/2 x 6 in), watercolour

Wet-in-wet blends of watercolour are perfect for cloud formations. Dark tones for the shadowy bases can be touched into wet washes and allowed to spread.

En plein air

If you are brave enough to try a full painting, take time over your composition and drawing to familiarize yourself with the subject before venturing into colour.

Painting outside in the open air is special whatever the results you achieve. You become lost in concentration, and vet completely aware of every nuance of changing light and knowing the passage of the clouds without looking up. Time passes unaccounted: asked how long your painting took, the chances are you do not know. When you return home the satisfaction felt is beyond measure.

Above: Cricket Match in the Stour Valley 18 x 25 cm (7 x 10 in), watercolour In this half-hour sketch painted at a cricket match the figures are marked with a pencil and left out of the hedge wash as vague white paper shapes. Watercolour is great for speed.

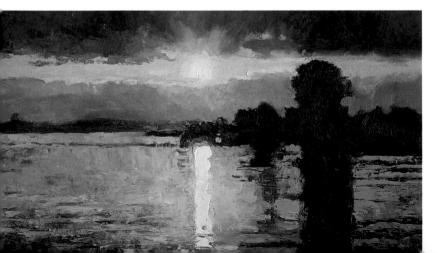

Left: Liquid Gold 20 x 33 cm (8 x 13 in), oil on board The reflection of the sky in water makes a strong composition as the similarity of the top and bottom halves of the painting create an almost abstract quality.

Country details

Instead of painting one view in the landscape go into the countryside and find a pleasant location. Look at the small fragments that belong to it, move close to them and spend an hour or two painting as many details as you have time for. I prefer working in watercolour outside, but use whatever medium you enjoy and find most convenient.

MATERIALS USED watercolour

FORM AND TEXTURE

The wire latch over the gatepost is evocative of lots of country walks. The texture of the wood is built up with wax resist and dry brushwork.

FPHFMFRAI WASHES

The two main techniques of watercolour, wet-in-wet and wet-on-dry, combine well in paintings of organic subjects. The ambiguity caused by the alternating clear and blurred edges suggests movement in the leaves.

SUGGESTIVE DESCRIPTION

Even if a subject has definite form and edges you are not obliged to demarcate every one. The suggestion of detail on this log is more evocative than literal description. Use wetin-wet technique to soften edges and create some ambiguity.

postscript

The appeal of watercolour lies in the quality of the transparent tints and washes, so a detail is as valid as a view.

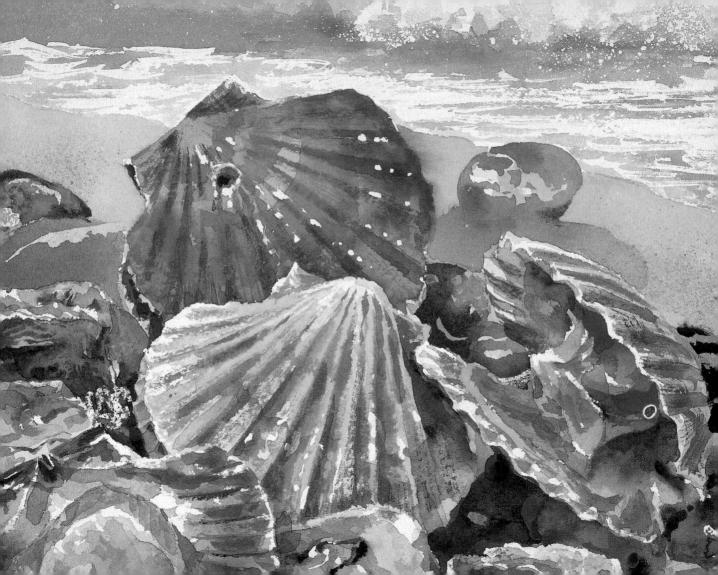

Inspiration on holiday

The time to relax is when you don't have time to relax.

For some people the only real time they have available to paint is on holiday. Happily this is usually a time of new inspirations and fair weather and it therefore offers boundless subject matter for the painter.

There are always the obvious painting choices, such as famous buildings and striking landscapes. Certainly, remarkable architecture and memorable places are good subjects and are frequently painted as a result, but trying to paint them in a slightly different way from the usual view can be a more exciting challenge.

There are also less predictable images that may evoke your holiday in a more

personal way, as well as countless other subjects that are part of holiday experiences and which can make fun paintings and wonderful memories.

Travelling light

First, you have to decide which medium to use and which materials to carry. Some airlines no longer allow the carriage of oil paint, but in any case I favour the use of watercolour on holiday because it is light to carry, dries quickly and is clean to use in hotel rooms or someone else's home. The pigment mixes with easily available water and watercolour paper packs flat.

There is no need to take an easel or even a stool. In most circumstances you will be able to rest your sketchpad on your knees and find a suitable perch such as a bench, wall or rock. The main thing is to be comfortable and to have your materials within close reach so you can concentrate on the painting.

To prevent sand or grit blowing into your palette place a plastic bag and kitchen towel under your materials.

Oysters and Scallops (detail) 26.5 x 19 cm (10 1/2 x 7 1/2 in), watercolour

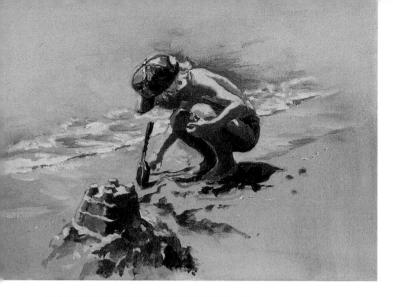

Above: Castles in the Sand 20 x 25 cm (8 x 10 in). oil on tinted canvas

Children grow so quickly, but sketches made on the spot or from holiday photos, can catch a moment forever. Leave out everything but the essentials, and you have a poignant little painting.

Left: The Doorman 18 x 18 cm (7 x 7 in), watercolour Hotels, restaurants and bars never seem to mind the presence of an artist. This image of the Ritz Club in London is evocative: a sense of mystery is created by small areas of obscurity behind reflected glass.

Family fun

Children playing in the sand and sea are an all-time favourite subject. They are even more charming if they are your own. so take your sketchbook to the beach. Figures stretching, crouching or bending. or dressed in swimming costumes, are as good as going to life classes!

Look for the shape of the pose, reflections in wet sand, and the close setting. Or just paint the buckets and spades - their bright plastic colours will add zest to any sketchbook.

Sunshine and shadows

The patterns of strong contrasts created between light and shade make interesting subjects. Blazing sunshine and whitewashed walls give opportunities to the watercolourist for using the brightness of the white paper as the lightest highlights.

Look at the colour of shadows. On white walls they are usually blue or mauve, seldom grey. In oils and acrylics a glaze of colour over a dull shadow will soon enrich it

Taking a camera

The camera can be an invaluable tool on holiday. If you have a long lens, zoom in on details from a distance and use the lens as you would a viewfinder.

When you paint from your photographs beware of being a slave to the image. As with real life look for a balance of tones and an interesting composition within the photograph itself.

Windows, hotels and rooms

Windows give a great sense of personality and place. Painting just the window of a building makes an interesting subject, and one that can be completed in a short time.

Henri Matisse and Pierre Bonnard often painted the view through the window, incorporating the balcony, window frame or part of the room into the painting. This view within a view makes an interesting double composition and holiday apartments and hotels may offer the perfect opportunity to try this out. Assess the tone of the room against the view

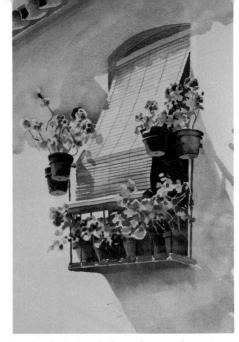

to check their relative values and create a sense of 'throughness' from one world to another.

What about the hotel itself? When it rains, do you retire to the bar and drown your sorrows in sangria or, instead, open the paintbox and paint the lobby or the hotel room. These paintings can later evoke memories of an era, a time and a place.

Above right: Window in Estepona (detail)

46 x 36 cm (18 x 14 in), watercolour In the Mediterranean region highly decorated windows become real-life paintings and sculptures. The strong blue shadows add a touch of drama to a pretty subject.

Carpe diem

You may find yourself with friends who are not interested in waiting for you to finish a painting. If this is the case seize the moments when you are all at rest; for example, sunbathing on the beach, sipping beers or coffee, or taking a siesta. Tans fade, memories do not, and you will not regret the time spent painting.

Holiday characteristics

Different places have different characteristics that in some way evoke or sum up the location. When you are choosing views to paint look for whatever it is that in your opinion most aptly portrays the essence of the place. It could be the predominant colour or patterns of the brickwork, the type of vehicles, the species of trees or local crafts and customs.

Trying to paint the spirit of the locale makes you look more thoughtfully at the visual inspiration and adds weight to your paintings. Small vignettes can be grouped together as a montage.

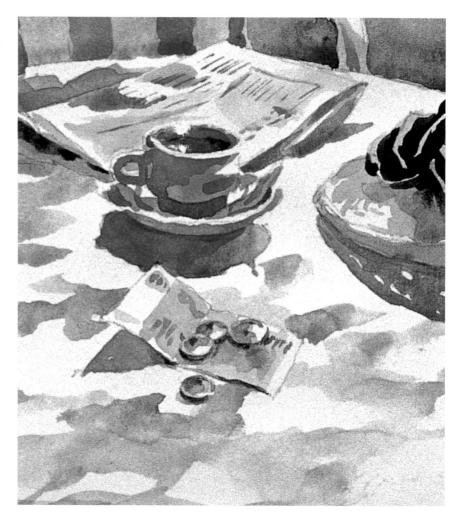

Left: Seizing the Moment 18 x 13 cm (7 x 5 in), watercolour

On holiday companions sit for a long time over beers and coffee. watching the world go by. Enjoy the company with time to paint the people, the café, the empty coffee cups, or even the bill and change on the saucer.

Right: The Slopes 20 x 28 cm (8 x 11 in). watercolour Simply mix up dull greens for the trees and blues for the shadows and say it all in a few brushstrokes!

Below: Roofs in Villefranche 20 x 28 cm (8 x 11 in). oil on paper

The palms and red tile roofs so typical of the South of France epitomize for me the cheerful atmosphere of Mediterranean towns. This church tower made the perfect focal point for a painting.

Winter holidays

This is a great subject for watercolourists: reserving the white paper for snowy landscapes! If watercolour freezes it makes the most lovely patterns on the paper as it thaws, and numb fingers are a small price to pay for such texture.

Acrylics offer the enjoyment of working from dark to light and in oils few colours are needed, which enables the artist to keep the painting crisp and clean. Tone is of utmost importance as the virgin whites dazzle the eyes. Lay your brushstrokes so that they help describe the contours of the white landscape. Look for elongated turquoise and blue shadows cast by the low winter sun, giving dramatic contrasts.

The Wave 28 x 36 cm (11 x 14 in)
Viridian is used in different densities of transparency to paint the shape of the rising wave.

Beachcombing and shorelines

Along every shoreline lies a plethora of abandoned shells, sea life and debris. The colours and textures of these items are delightful to paint. Shells present boundless colours and shapes that are especially good for the watercolourist.

Each beach is characterized by unique features: battered groynes, rock pools, abandoned spades and such. You need only paint these items as still lifes, and let memory and imagination dream of the settings. Driftwood also tells a story.

For a seascape position your viewpoint to bring chosen features into focus, making them large in the foreground. Dune grasses, for example, bending in the wind, tell you about the openness of the beach, the strong breezes, the sandy dunes; lower your eye level to allow them to dominate the foreground.

Rocks and stones

All the colours and patterns under the sun reside in a handful of pebbles washed up on the shore. Boulders, much larger in size, come in hundreds of different shapes with seams of quartz and granite to pattern their surfaces. Huge rocks, round and friendly, sharp and angry, have deep fissures that demand strong indigos and sepias neat from the tube.

The three-dimensionality of rocks and stones make them excellent material for practising the gradations of tone across a surface to make something look round. Once form is in place concentrate on surface details, texture or pattern.

The sea itself

Paintings of the sea itself can be really interesting, especially if there is implied movement of the water.

In watercolour leave the white paper for the foam, or scratch the surface of the paper to reveal white from underneath a wash. In oils and acrylics you have marvellous opaque white paint that can be ladled on thickly with a palette knife or brushed on with swift, energized strokes to create the spume and spray of the churning sea.

Waves

Waves themselves make a fascinating subject. Watch the rise and fall, the ebb and flow for a while before deciding the shape of the waves you want to paint. You cannot paint them all; you must choose, and then summarize.

Look closely at the colour of the rising wave - the translucent viridians, the green-golds of the water, before it curls over and crashes down in milky whites.

Above: The Wild Sea 56 x 76 cm (22 x 30 in), oil on paper Strong tonal compositions can be painted along shorelines where limited local colour readily takes on shades of greys.

Below: Next Stop. Brazil 41 x 51 cm (16 x 20 in), watercolour The illusion of great distance can be suggested by the ever-reducing size of stones as they recede into the background. The narrowing of the beach on the picture plane also aids the impression of distance.

Panoramic vision

The 36o-degree vision that beach scenes offer the artist often makes it hard to decide on the subject to paint. Wide, empty spaces and stretches have commanding atmospheres, and can be kept really simple. Or look for a focal point of interest, such as a line of groynes, a large rock, figures, a dog running, or a shapely wave.

Use your viewfinder and quick line sketches of potential layouts to assure yourself the composition is not boring, too predictable or complacent. If in doubt try raising or lowering the horizon line. More sky might have more impact than more beach.

Atmospherics

With brooding skies and stormy waters, inclement weather makes a great subject for the sea painter.

Use limited colours and ensure that the sky colour is reflected in the sea to keep the areas above and below the horizon in harmony.

Ocean Stream 20 x 28 cm (8 x 11 in), oil on canvas The same sense of exhilarating calm felt by being near the sea in real life can be created in an uncluttered painting. That a small flat board daubed with a few colours can give a sense of wide, open space is, to me, still amazing.

River of Gold 91 x 91 cm (36 x 36 in), oil on canvas Indian Yellow is a really hot yellow, ideal for the colour of the setting sun. The small boy bending to the stream of the tide gives scale to this atmospheric painting.

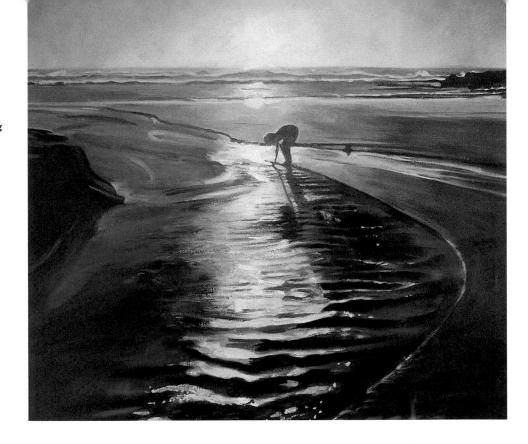

If you want to create a sense of distance use the fact that cool colours recede and warm colours advance. 'Blueing' colours in the background can enhance the sense of space. The earth's atmosphere changes and pales colours, so remember to lighten the tones and soften the hues from the foreground to the background.

DEMONSTRATION IN WATERCOLOUR

Fishing Boats

Fishing boats are fun to paint because of their interesting shapes and vibrant colours. I chose three that were bobbing gently by the jetty. The definition inside the hull and the blur of reflections around the hull allow the watercolourist the chance to use a happy combination of wet-in-wet washes and wet-on-dry brushwork.

COLOURS

Prussian Blue
Cadmium Red
Cadmium Yellow
Viridian
Cerulean
Cobalt Blue
Yellow Ochre

- 1 The boats are specific shapes, so I made a careful pencil outline of the hulls relative to each other and used a little masking fluid on the gunwales. I washed in Prussian Blue for the surrounding sea and shaded sides of the hulls, plunging Cadmium Red into the wet paint beneath the forward hull and allowing it to spread softly as a reflection.
- 2 I mixed Cadmium Red and Prussian Blue together to make the rich darks of the insides of the hulls. I reserved the shapes of the seat planks from the washes. The yellow boat was full of boating clutter, so I indicated this with wet-in-wet washes and reserved highlights.
- 3 With the forms established I started on the features. I painted the yellow stripes with Cadmium Yellow and Yellow Ochre. I painted the reflection at the same time, brushing the dark water colour against the bottom stripe and allowing the colours to merge. I touched in the seats with Viridian and Cobalt Blue.

4 The deep, dark reflection under the furthermost boat links the three boats together. I brushed this in with Prussian Blue, wetting the area between the boats so that it would blend into the blue already there.

As it dried I lifted out the ripples horizontally with the tip of the brush. I painted the stripes on the other two boats, carefully following their form. Finally, I brushed a few ripples across the blue wash to ruffle the sea.

Holiday sketches

This is your holiday, so whatever you do must be fun and relaxing. Take a sketchbook and fill it with different visual notes, incidents and anything to do with your holiday. Do not worry about composition or finish; just use your paintbrush as your eyes.

MATERIALS USED watercolour sketchbook

LOCAL ATTRACTIONS

A quick stop by the roadside affords only time to look at the shape of this twisted olive tree, but I enjoyed painting even a half-finished study and I had the chance to really look at the bark of the tree.

THE PERSONAL TOUCH

could be sunglasses and a coke can, a hat and flip-flops, the hotel bill or an 'in' joke about some irritation. Make some small paintings of these memories.

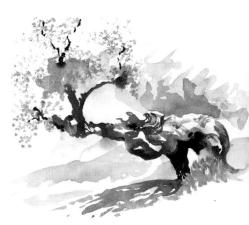

CATCHING THE ACTION

People on beaches make great life models. As one moves off another takes up a similar pose. Sketch as many poses as you can as quickly as you can. Look at overall shape; do not worry about detail.

LOADED BRUSHSTROKES

Painting the shape of something with one colour only is also satisfying. The tip of the brush starts at the beak and then the body of the brush is pressed down to release paint for the torso and lifted up again to the tip for the feet - so just one brushstroke.

postscript

The more you paint the more you want to paint, so even if you feel unsure of what you are doing, just have a go. Inspiration often kicks into higher gear after you have started, and the trouble is you will not want to stop!

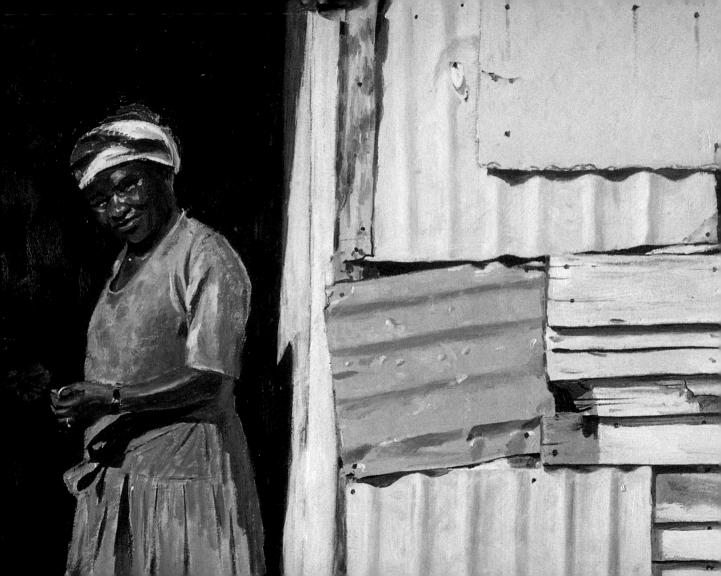

Inspiration further afield

... so difficult is it to be natural, so easy to be superior in our own opinion.

> Nowadays many people take vacations not for relaxation and leisure but to experience other cultures and climates. Others are posted for their work to places beyond their own background. In foreign and exotic locations it is easy to spot good subjects from among the unfamiliar surroundings.

Keeping a journal

An excellent way to respond to what is around you is to keep with you a diary-cumsketchbook that records both visual and conceptual stimuli. Travellers' sketchbooks bristle with interest on every page. To make life simple draw with the same implement

you use for writing - a pencil, waterproof felt-tip pen or mapping pen. These are all perfect accompaniments to watercolour, which is the easiest medium to carry around on lengthy travels. Choose a convenient size sketchbook that will also take the written word without difficulty. Carry your water in a small sealed jar and keep everything in a lightweight bag.

Into your book you can also paste tickets and stamps and visual memorabilia that represent landmarks of the journey and places you have visited.

Mutual courtesy

Always be aware that in some countries, especially in Africa, people may not like their photograph taken, and this may even extend to painting. Different cultures react differently to the artist in their midst. In Africa the children form a delightful crowd all around, leaving an arc of vision for the artist to see the subject. In India both adults and children are curious; they crowd so close that it is often difficult to see the subject beyond the fray.

Chez Elsie (detail) 38 x 56 cm (15 x 22 in), oil on board

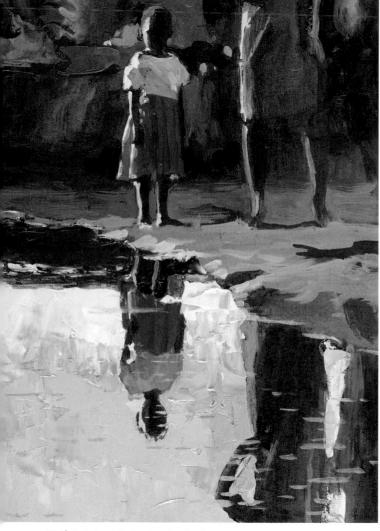

114 Artist's Little Book of Inspiration

Romancing the tone

It is easy to romanticize that which is foreign to our daily life, and especially poverty. Shanty huts make delightful painting subjects with their quaint shapes, odd colours and myriad textures, but for those who reside in them living is hard and ablutions uncomfortable.

Above: Rush Hour, Agra
10 x 15 cm (4 x 6 in), watercolour
Watching the endless stream of
bicycles cross the river bridge near
the Taj Mahal I could not resist
making a little painting.

Left: Another World 30 x 20 cm (12 x 8 in), oil on board The reflection, a powerful compositional element, is used to make a poignant statement about this little girl's life.

Zulu Beads 20 x 20 cm (8 x 8 in), watercolour I was totally entranced by the colours and patterns of the beads. I zoomed in really close to concentrate on them alone.

This does not mean we need feel guilty painting, but we must be aware that what might be a happy subject for an afternoon's painting represents a very different lifestyle to someone else. Usually the artist is greeted as a welcome diversion, especially by the children.

The microcosm

Aside from the amazing landscapes, unusual lifestyles and colourful costumes, look at the minutiae of the landscape, the little details that also make up the ambience of a place. The simple can be just as inspiring as the obviously exotic. Remember to zoom in and out of any view. The earthenware pots, hunky beads and local foods are the still-life staples of these other lands. The timeless nature of some of these items can be captured in even a quick study.

Colour and character

Never paint what you feel is required or expected of you, only what really interests you. Enough people have made a record, and your contribution is unique only if you bring something to your painting that is peculiarly your own.

Painting is not the same as depicting, just as writing is not the same as describing. Everybody will tell a different story about a visit to the same place.

If colour is your inspiration you will find it in abundance. Colourful dyes are one of the attractions of the African and Asian continents. Women in immaculately clean saris wash their clothes in the muddy waters of a river. African girls decked in patterned sarongs elegantly carry baskets upon their heads. The dashes of bright colour enliven any view, and when doubled by reflection in water they provide a field day for painters.

Find poses that say something specific about the men, women and children of the place. Faces alone can tell a tale, whether in the large languid eyes of the infant or the folded skin of the elder. If you are only passing through be aware that your responses are based on immediate impressions only. They may not represent the reality, but that does not lessen their validity or purpose.

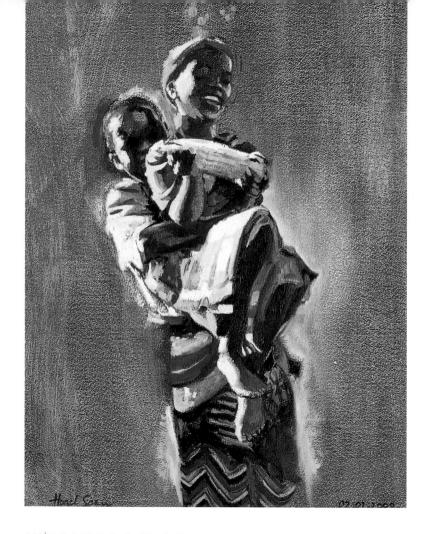

Painting the intangible

There are also many intangible subjects to paint, such as community, tenderness, sadness, dignity. First, we must feel whatever we want to portray, then find the physical subject we think represents that emotion or concept. Next, we need to choose the appropriate medium and use colour and tone to good effect. Bright, warm colours denote cheerfulness and positive mood, while cool, blue, muted and dark colours can signify sorrow, hardship and negativity.

Out wild

To go into wilderness areas beyond the habitation of man is an invitation to endless inspiration. There is plenty to paint in this kind of environment, although some of it moves too fast for the brush to record! Just sitting, watching and listening, to absorb the ambience, is the best way to begin.

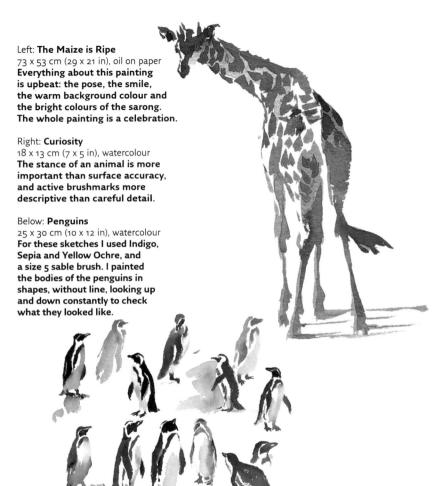

Painting animals

If you are painting animals watch with a pencil in hand. Keep your eyes on the animal and draw its moving shape over and over on the paper. Once you feel more familiar with its lines you are ready to work with a brush and to paint in the shapes of the bodily form. Work in monochrome before thinking about colour. Lively sketches can be made in this way, which you can use as reference later, or enjoy just for themselves.

Backgrounds and settings

Setting your wildlife in a background is not always necessary. If you are painting in great detail the composition needs to be planned, but if you just want to evoke an environment you will find that loosely washed backgrounds are sufficient. To give the painting a warm atmosphere wash a pale Yellow Ochre or Burnt Sienna over the paper before painting on top. If you want to retain lighter highlights they can be left out of this wash or lifted out from this wash while it is wet.

Lake Kariba 18 x 28 cm (7 x 11 in), watercolour The majesty of African elephants moving through the bush needs little in the way of background. The blended washes of watercolour evoke the setting and leave us to imagine the journey off into the vast African expanse.

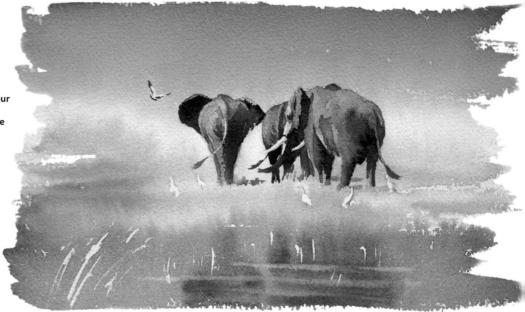

Finished paintings

To make large compositions in the wild is difficult. In most places proximity to wild animals is dangerous and you must either stay in your vehicle or campsite or work within the protection of a hide.

The camera is therefore invaluable for the information you cannot record in paint. When you are transcribing from

photographic reference in the shelter of your studio try to take yourself back into the wild, so that the fleeting movement is not stiffened. I used to have a refrigerator that whirred like the sound of cicadas in the bush: painting in its proximity sent me straight back on safari!

Limit interruptions so that your concentration remains intact.

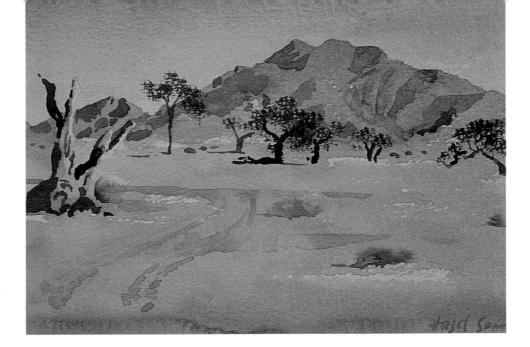

Road to Nowhere 20 x 28 cm (8 x 11 in), watercolour If, as I do, you like simple landscapes and avoid green, the desolate expanses of desert will thrill you. The air is sometimes so clear, as seen in this painting, that the tones remain as strong in the middle distance as they are in the foreground.

Exposure to the elements

The effects of time and weathering always offer exciting opportunities to the painter. In the wild the bleaching of bones, the weathering of dead wood and the cracking of earth are all interesting subjects in themselves and can also be transferred into paintings to provide authentic settings or focal points.

Desert landscapes long ravaged by lack of rain come in the most splendid colours of red and orange, ochres and purples. If you need a focal point to carry the eye into this cauldron of colour, look for a tree stump, tyre tracks or a lone animal.

Even a few blades of grass breaking the horizon line can be enough to energize a mainly horizontal composition.

DEMONSTRATION IN WATERCOLOUR

To the River

Painting on the hoof, so to speak, requires minimum equipment and time. When I am in the bush I carry very few colours. Any combination of blue, red and yellow will give you a satisfactory range for most natural subjects (see the colours I have chosen). This painting was made in the studio from photographs to show you how it is built up, but the process would be similar in the wild.

COLOURS Prussian Blue Alizarin Crimson Yellow Ochre

- 1 The herd of elephants is moving across the road. There is no time for a preliminary drawing, so the shapes of the elephants are painted straight onto the paper in a tone equivalent to the light areas of their bodies. As one moves on another follows in a similar pose, so each painted elephant is likely to be made up of a number of real elephants!
- 2 The road is now empty, and the elephants have gone down to the river, so the background is washed in with soft wet-in-wet washes of Prussian Blue and Yellow Ochre. Directional brushstrokes are used for the road to indicate the rutted texture. The shadows of the bush across the road are merged with the greenery at the side.
- 3 In real life I would move to where the elephants were drinking to paint the forms of their bodies, or wait for them to cross back over the road. But, using photographs, I carry on by darkening under the bellies and behind the ears to create their bulk. Rich dark mixes. kept wet allow merging across the body form.

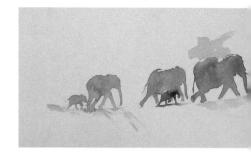

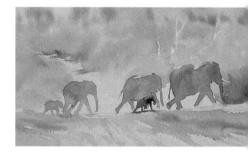

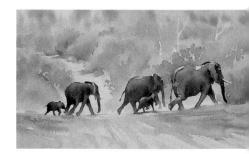

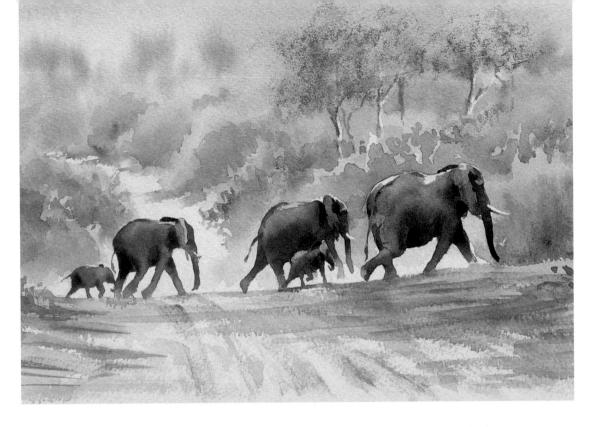

4 The foliage of some distant trees is sponged in with a small natural sponge. The foreground is too light, so a stronger shadow is cast across the foreground and the ragged verges are emphasized with

stronger ochre and green. A touch of Alizarin Crimson into the background foliage ties the elephants and their surroundings together colourwise, creating a natural harmony in the landscape.

From the heart

Reality is one part of art; feeling completes it ...

Corot

The best paintings come into being through involvement. The greater your interest in the subject the more likely you are to enjoy the unfolding of the image on the surface of the painting. If you are not excited by your subject there is no point in painting it.

I believe love of the subject, love of painting, love of life itself, translates directly onto the painted surface.

Zeal for the subject

Painting can express the intangible. Using composition, colours and tones that emphasize emotions the painter can evoke in the beholder a similar sentiment. Before any subject abandon yourself to your first impression. If you are really

moved your painting will convey to others the sincerity of your feelings.

Even if you have mastered technique a painting that lacks enthusiasm will be sterile. This is good news, because it means your fervour is more important to the painting process. It means that at any point in learning to paint you can make something worthwhile. This should give you courage. It will help prevent you overworking a painting, when in fact your statement is already valid.

Imagination

For me visual inspiration comes from the physical world and the spirit it depicts. The enjoyment I experience from painting is the pleasure of seeing and translating what I see into paint. I do not really enjoy working solely from my imagination.

Some people, however, love to absorb what they see and paint from memory later. If you prefer to do this, bear in mind the prerequisites of the painted surface and use composition, form, tone and colour to create the painting.

Standing Alone 11 x 20 cm (5 x 8 in), watercolour

Visual memory

If the information is not physically in front of your eyes you have ultimate control over your subject together with total responsibility for it.

A good visual memory for shape is a wonderful asset; to be able to sketch from life and then to remember those shapes at a later date without reference is a gift. But if you do have this ability, when looking at a familiar subject forget what you know and observe the site or object as if you have come upon it for the first time. When someone says to me, 'I know how to draw horses', I am instantly on guard. A formula for making horses look like horses will impress, but not inspire. Use your asset if you have it, but remember to refresh it continually.

Inspiration ad infinitum

In an organized art class you might be asked to paint subjects that would not be your automatic choice, but if you have trained your eye to see shape, line, colour and tone, and to delight in these

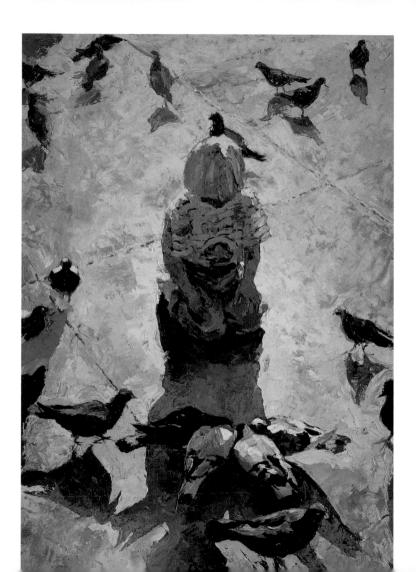

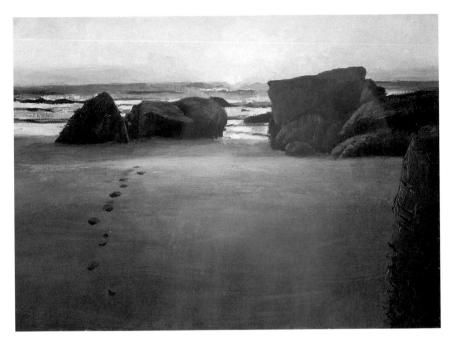

Left: Feeding the Five Thousand, 56 x 41 cm (22 x 16 in), oil on paper This painting was inspired by my son's love and care for all God's creatures.

Above: Hiding Place 25 x 30 cm (10 x 12 in), oil on board A child saw his parents admiring this painting in my studio. He told his mother he liked the painting, but please would she not buy it as she would always be worried where he was: the footprints went out to the rocks, but did not come back. Paintings speak louder than words.

elements instead of the subject per se, you will find very little that is not interesting to paint.

Once you start to look at any subject with a view to making a painting, the problems and opportunities are all the same: the needs of the two-dimensional picture plane, composition, colour, tone and texture. If you cannot find these elements in the wider view, narrow your field of vision until you reach the simplest details of life. Somewhere there is something that inspires you or you would never have picked up a paintbrush in the first place. There is no subject too humble, no subject too daunting.

As you get to know the subjects that you enjoy as a painter these catalysts will become more and more apparent to you. Practise painting whenever and wherever you can. Soon you will be crying, 'Stop! Enough! There's not enough time in the day to paint all the exciting things I see.'

Viewing the world through an artist's eyes you will never be at a loss for inspiration again.

Gallery

Putney Riverside 25 x 36 cm (10 x 14 in), oil on canvas The geometry of modern architecture coupled with clear morning light makes an arresting composition.

In the Still of the Tide 25 x 36 cm (10 x 14 in), oil on canvas Repetition is a great compositional device. Here the mirrored reflection breathes life into an urban landscape.

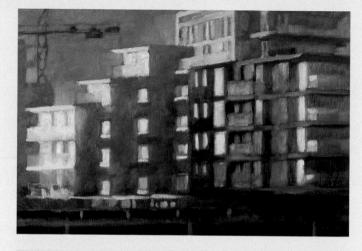

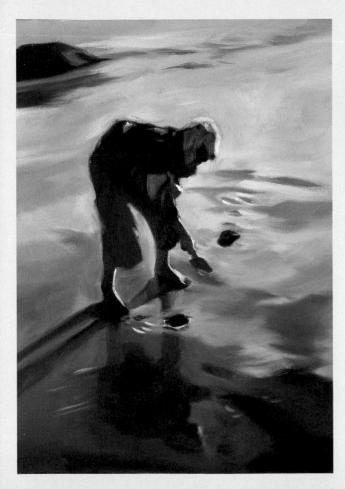

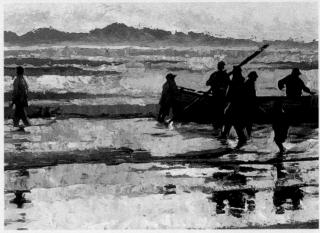

Above: Blue Dawn 43 x 76 cm (17 x 30 in), oil on paper Contrasting colours, blue and yellow, and contrasting tones, light and dark, are sure-fire inspiration for a painting.

Left: Beach Boy 51 x 41 cm (20 x 16 in), oil on canvas The red spade is pivotal to this tonal painting.

INDEX (Page numbers in bold type refer to illustrations)

acrylics see oils and acrylics animals and wildlife 28, 39, 43, 56, 59, 65, 74, 74, 93, 111, 117, 117, 118, 118, 120-1 atmosphere and mood 22, 32, 33, 41, 41, 51, 84, 93, 93, 102, 106, 106-7, 114-16, 114, 117, 125

balance 21, **22**, **23**, 27 boats **17**, **56**, **63**, 64, 108-9, **127** boundaries 21 brushes 55 brushstrokes 32, 55, 56, 72, 74, 103, 111, 117 buildings **17**, **40**, **51**, **74**, **80**, 81, 81, 86-7, 100, 101, **101**, **103**, 114, **126**

canvas 58, 59, 62, 93
children and family 13, 19, 51, 72, 73, 84, 100, 100, 107, 114, 125, 127
clingfilm 49
colour 29-35, 41, 46, 55, 62, 66, 85, 92-3, 115
complementary 29, 30, 30, 31, 46, 62 mixing 34-5
temperature 32, 34-5, 84, 93, 107, 116, 117
composition 21-7, 22, 23, 25, 41, 46, 56, 66, 81, 83, 106
contre-jour painting 39, 39, 50, 63, 73
countryside 41, 89-97, 103, 103

demonstrations 76-7, 86-7, 108-9, 120-1 deserts 119, **119** distilling the subject 17, 19

emotional involvement 17, 19, **51**, 61, 116, 123, **125** events 94, **95**

fabrics 46, 73 figures 13, 25, 39, 40, 58, 59, 66, 72, 82-3, 83, 84, 100, 111, 115, 117 flow lines 25, 46 focal points 25, 106, 119 foliage 46-7, 47, 92-3, 97 fragments and details 17, 27, 46, 46, 89, 91, 91, 96-7, 110, 115, 115

gallery 50-1, 66-7, 126-7 gardens and yards **30**, **47**, **74**, 75 greens 92-3 greys 85

highlights and whites 40, 43, 93, 103, 117 holidays and travel 99-111, 113-21 home 71-7 homing in 14, 15 horizons 23, 25, 41, 64, 84, 106 hotels 100, 101

improvisation 61, 63, 69 inks 43, 56, 65, 74 interiors 26-7, **33**, 43, **66**

landscapes 22, **62**, 89-95, **103**, 119, **119** light 29, 31, 37, 39-40, **39**, **50**, **63**, 71, 79, 81, 90-1, 100, 107

materials and equipment 53-9, **66**, 99, 113

media, selecting 55-6, 61-5, 116 memory 123-4 monochrome painting **38**, 42-3, 65, 117

oils and acrylics 40, 55, **56, 57**, 62, **62, 63**, 76-7, 85, 86-7, 90, **90**, 93, 100, 103, 104 surfaces and grounds 57, 58, **58**, 59, 64, 93 textures 45, 49, 56 outdoor working 80, 90, 95, 99

palette knives 49, 57 papers 57-9, 62, 64 perspective **14**, 81, 84 photographs 101, 113, 118 picture plane 25, 45, 46, 84 portraits **33**, 46, 64, 72-3, **72**, **73** projects 18-19, 26-7, 34-5, 42-3, 48-9, 64-5, 96-7, 110-11 proportions **12**, **14**, 19, 73

recycling 64 reflections 81, **81**, **85**, **95**, 109, **126** repetition 25, 46, **126** rocks and stones **23**, 48-9, 104, **105**

salt crystals 45, 48 seascapes and beaches 13, 23, 48-9, 57, 63, 64, 104-7, 104-7, 111, 127 seeing 11, 12, 18-19 shadows 31, 40, 40, 85, 90, 92, 92, 100, 103, 103 shapes 12, 13-14, 13, 14, 15, 18, 18, 25, 26, 50, 117

simplification 15, 15, 17, 40, 81 sketching 22, 63, 80, 90, 94, 106, 110-11, 113, 117 skies 23, 81, 91, 94, 95, 106 spaces 12, 13, 13, 18, 18, 19, 38 sponging 45, 48, 56, 93 still lifes 14, 18, 22, 25, 38, 41, 43, 59, 71, 75, 76-7 subject selection 9-17, 17, 123-5 see also specific subject areas (eg countryside) surfaces and grounds 56-9, 56, 58, 59, 62, 64-5, 93

texture 45-9, **46**, 56, 96 tone and tonal values 26, 37-43, **38**, **39**, **41**, 48, **50**, 71, 90-1, 104, **105**, **127** townscapes **14**, **50**, **63**, 79-87, **80-5**, **103**, 114, **114**, **126** two-dimensional thinking 11, 12, 21, 22, 25, 37

vehicles 82, **92**, **93**, **114** viewfinders 22, 27, **80**, 106 viewpoint **66**, 84-5, **85** visual memory 124

watercolours 40, **41**, 45, 48-9, 55, 57, 58, 62, 63, 85, 92-3, 99, 100, 104, 108-9 wet-in-wet **40**, 74, **74**, **95**, 97 weather 51, 79, **81**, **82**, **90**, 91, 92, 106 windows 101, **101** wood **56**, 59, 64